[THE WORLD OF JEFFREY VALLANCE]

The World
of Jeffrey Vallance

[COLLECTED WRITINGS 1978–1994]

Edited by David A. Greene
and Gary Kornblau
Introduction by Dave Hickey

Art issues. Press
Los Angeles

The Foundation for Advanced Critical Studies
8721 Santa Monica Boulevard, Suite 6
Los Angeles, California 90069

First Edition

Art issues. Press is a division of The Foundation for Advanced Critical Studies, a nonprofit California corporation.

This publication has been made possible through the generous support of Lannan Foundation. Additional funding has been provided by The Andy Warhol Foundation for the Visual Arts, the Peter Norton Family Foundation, the National Endowment for the Arts, and the California Arts Council.

Designed by Linda Norlen

Manufactured in the United States of America

Library of Congress Cataloguing in Publication Number: 94-71893
International Standard Book Number: 0-9637264-1-2

Contents

ILLUSTRATIONS

All works courtesy of the artist and Rosamund Felsen Gallery, Los Angeles, unless otherwise indicated. DP = Photograph by Douglas M. Parker Studio.

page 14 *Blinky Medusa Octopus*, 1990. Watercolor on paper, 7 1/8 x 11 1/4 in. Courtesy of Galerie Antoine Candau, Paris. (DP)

page 18 *Cockatrice*, 1988. Marker on paper, 19 1/2 x 29 5/8 in. *Blinky Cock*, 1988. Marker on paper, 16 1/2 x 14 in. Collection of Barry Sloane, Los Angeles. (DP)

page 22 *Blinky Tiki*, 1988. Marker on paper, 19 1/2 x 29 5/8 in. Collection of Barry Sloane, Los Angeles. (DP)

page 24 *The King of Tonga in His Various Roles: Tuimalila Tortoise*, 1985. Marker, crayon, and pencil on paper, 13 3/4 x 11 in. Courtesy of Marc Jancou Gallery, London/Zurich. (DP)

page 29 From *The King of Tonga in His Various Roles*, 1985. Marker, crayon, and pencil on paper, 13 3/4 x 11 in. From top, left to right: *Chancellor*, Courtesy of Marc Jancou Gallery, London/Zurich (DP); *Royal Wedding*, Courtesy of Marc Jancou Gallery, London/Zurich (DP); *Commander*, Collection of The Walt Disney Company, Burbank (DP); *Businessman*, Collection of The Walt Disney Company, Burbank (DP); *Traditional Tongan*, Courtesy of Marc Jancou Gallery, London/Zurich (DP); *Head of State*, Collection of The Walt Disney Company, Burbank. (DP)

page 33 *White Bat*, 1987. Acrylic on canvas, 24 x 31 in. Private collection. (DP)

page 37 *Sacred Bat*, 1987. Acrylic on canvas, 24 x 31 in. Private collection. (DP)

page 38 *Island of a Million Dogs*, 1983. Pencil on paper, 14 x 11 in. (DP)

page 42 *The Monster Eel (Hina and Tuna)*, 1988. Pencil on paper, 23 x 29 in. (DP)

page 48 *The Sanctuary of the Turtle and Shark and the Village Chanters at Vaitogi*, 1985. *The Monolithic Foot of Giant Pisi at Agagulu Coastline*, 1985. Illustrations from *Tariff Pago Pago*, by Joan G. Holland.

page 49 *The Samoan Cannibal Siamese Twins Taeme and Tilafaiga*, 1985. Illustration from *Tariff Pago Pago*, by Joan G. Holland.

page 52 *Landmarks of the West San Fernando Valley: Aku-Aku Inn*, 1985. Enamel on paper, 11 x 14 in. Collection of The Walt Disney Company, Burbank.

page 54 From *Landmarks of the West San Fernando Valley*, 1985. Enamel on paper, 11 x 14 in. From top, left to right: *The Platt Building*, Collection of The Walt Disney Company, Burbank; *Valley Assembly Hall of Jehovah's Witnesses*; *The Del Moreno Building*; *The Batman A Go-Go*, Collection of The Walt Disney Company, Burbank; *The Chateau*; *The Local 7-Eleven*, Collection of The Walt Disney Company, Burbank.

page 56 *Landmarks of the West San Fernando Valley: Los Angeles Pet Memorial Park*, 1985. Enamel on paper, 11 x 14 in. Collection of Lawrence M. Kauvar, San Francisco.

page 60 *Icelandic Drawing: May 10*, 1984. Pencil on paper, 11 x 14 in. (DP)

page 64 *Icelandic Women and Fish: President*, 1986. Crayon and pencil on paper, 14 x 16 1/2 in. Private collection. (DP)

ACKNOWLEDGEMENTS

"Blinky, the Friendly Hen" was originally published in *Art issues.* #5 (Summer, 1989); portions also appeared in *Blinky* (artist's book, ed. 550, 1979). A version of "Tonga, the Abode of Love" was published in *Forehead*, vol. 2 (October, 1989). "Diet of Worms: I Joined the Samoan Police Force" was originally published in *Art issues.* #22 (March/April, 1992). *Samoan Myth of the Cannibal Siamese Twins* was published in *RUH-ROH!* #1 (December, 1992). "Avenue of the Absurd: Landmarks of the West San Fernando Valley" was originally published as "Mr. Vallance's Neighborhood: The West Valley Revealed in Words and Pictures" in the *L.A. Weekly*, Sept. 20-26, 1985. A version of "Iceland, Gateway to Hell" was published in *LAICA Journal* #41 (Spring, 1985). A version of "Fish Tales: My Meeting with Madam President" was published as "Icelandic Women and Fish" in *High Performance* #40 (Winter, 1987). A version of "Desk Job" was published in *Equator* #4 (1988). "Veil Lance: Three's a Shroud" was originally published in *Art issues.* #26 (January/February, 1993); portions of "Veil Lance" and "Prophetic Wound: The Stain of Washington" also appeared in "The Blinking Shroud," catalogue essay for "Stained Sheets/Holy Shroud" exhibition at Krygier/Landau Contemporary Art, Santa Monica (1991). *Searching for Bigfoot in the Eye of the Guadalupe* was written especially for this volume.

Blinky's Big Sleep (And Other Clues to the Interrelatedness of Just About Everything)

The world of Jeffrey Vallance is much like our own, with certain notable exceptions—the most notable of which is that Jeffrey Vallance's world is centered in the San Fernando Valley. It spreads out from there, of course, in latitudes and longitudes to encompass the entire globe, but its epicenter is there, in the Valley, in that vast, smoggy sprawl of quotidian American Arcadia—just over the mountains from Los Angeles, with whom it shares a culture, as Brooklyn shares one with Manhattan. Linguistically, the Valley is the fountainhead of a very annoying and virulently infectious teenage patois. Visually, the Valley is either not much or a whole bunch, depending on your authenticity requirements. If you require a lot of it, the Valley is a bummer, since, excepting some fast-food signage, assorted miracles of lowrider engineering and the translucent dreams that waft off the Universal lots, nothing much substantial comes from there. On the other hand, everything does end up there, in syndication—although, to the untrained eye, it all looks pretty much like the Valley.

In Mr. Vallance's neighborhood, then, the homes are a hybrid of Tijuana and Levittown; the 7-Elevens come from Dallas; Le Chateau on Ventura Boulevard comes from eigh-

teenth-century France and the Del Moreno Building from four-teenth-century Morocco; the Platt Building and the Los Angeles Pet Memorial Park have their roots in Victorian England, while the Valley Assembly Hall of Jehovah's Witnesses, I suspect, can trace its provenance back to Maurice Lapidus' Miami Beach of the nineteen fifties—which was about the time that the Aku Aku Inn made its way from Polynesia, across the Pacific with Thor Heyerdahl. Thus, of all the great monuments in Mr. Vallance's neighborhood, only the Batman A Go-Go in Canoga Park might be said to have a relative at home, being the bastard offspring of serial television and faux French sixties disco—but even there, on a Saturday night, if you get lucky, the go-go dancer will drape her skirt over your head and execute "The Veil of Ecstasy," in an obscene parody of the miracle of Saint Veronica that dates back through medieval Spain to the crucifixion of Christ.

The second critical difference between Jeffrey Vallance's world and our own is that its inhabitants do not regard them-selves as particularly "advanced" or "evolved." The differences between medieval Turin, tropical Tonga, and Canoga Park are more apparent than real to them; and this is understandable, when you remember that they live in the place where everything ends up—where authenticity comes to die. As a consequence of this fallen condition, inhabitants of the Valley, and particularly Mr. Vallance himself, tend to take a highly complex, flat-line view of history. So when Mr. Vallance sets out on those quests that take him across the globe—to Samoa or Iceland, or even to Rome, Italy—he crosses no evolutionary fault lines between advanced and primitive cultures. When he delves into history, he traverses no barrier between the enlightened present and the superstitious past. These distinctions do not exist in the world of Jeffrey Vallance; for him, it is the Valley all the way around, and he is its Herodotus, its Schliemann, its Candide, and its Von Helsing.

But most crucially, he is our Philip Marlowe, quite literally our private eye, with a private vision of pied beauty and sacred

banality in a world that extends to the horizon. And, like Philip Marlowe himself, Jeffrey Vallance aspires not so much to solve the mystery as to trace its filigree, to catch a glimpse of its invisible tumbling architecture. For him, the Valley, and the Valley world that spreads beyond it, is the domain of real fakes and fake realities, with no center, no edges, no top, no bottom, and no direction—a tattered sphere of overlapping neighborhoods and floating islands, where everything is interconnected, always interconnected, everywhere. And so, if Jeffrey Vallance owes a debt to any artist, he probably owes a debt to Raymond Chandler, who, back in the nineteen thirties, invented a way of writing about the ragged sprawl of Los Angeles, when it was just Los Angeles—before the world became Los Angeles.

Chandler borrowed some strategies invented by Joyce to capture Dublin and some idioms used by Dickens to capture London, and adapted these imported tricks to the tropical thoroughfares of Los Angeles by inserting a medieval hero into the narrative: a knight errant—a creature of the grail—a private eye, who can move through the city as others cannot, like a ghost. In this way, Chandler invented the quintessential model for postmodern narrative: the first armature around which the postmillennial city folds with ease, a narrative whose form quite naturally takes the shape of its content—the private-eye novel. In formal terms, Chandler invented Philip Marlowe as a kind of relentless, loving agency, a character at once outside the story and passionately involved in it, who can serve as a clear conduit for both the "front story" of the detective's progress in time and space, and the "back story," which apparently ends just before the front story begins.

Thus, Chandler uses Marlowe to tell a story that moves simultaneously forward and backward in time, circling inward toward some attenuated resolution while resonating outward into cultural ramifications. At the fulcrum of this forward-backward, inward-outward movement, there is a mystery—an

absence—bracketed by a disappearance and an appearance. The victim disappears, and Marlowe appears. Thus, in *The Big Sleep*, when the bootlegger Rusty Regan disappears and Marlowe is recruited to find him, Marlowe becomes a stand-in for Regan in the narrative, and his avenger as well. Not surprisingly, in the process of unraveling the complexities surrounding Regan's disappearance, Marlowe uncovers an even broader web of complexity and complicity, which he makes even more complex by systematically confronting and desacralizing those figures of authority whose job it is to make things simple: the policeman, the lawyer, the aristocrat, and the politician. This is the narrative function of Marlowe's wise-guy manner: to cast a private eye on authority and humanize it, subverting its pretense to elevated status and reintegrating its exercise into the democratic mystery of human beings feeling their way through existence.

In Philip Marlowe's world, then, as in the world of Jeffrey Vallance, the tragic disappearance of living creatures is leavened with the comic evaporation of authority. And considering this Chandlerian strategy of democratic confrontation, one cannot help but think of the disheveled and ingenuous Jeffrey Vallance before the King of Tonga, or deep in conference with the President of Iceland, or granted audience with Monsignor Sepe of the Vatican—for, although Vallance's stance is less Marlowe's wise guy than Warhol's innocent (who doesn't know that this *just isn't done*), the effect is the same. So, one can imagine Jeffrey Vallance standing on the sidewalk before the Aku Aku Inn on Ventura Boulevard, bemused by its absence of authenticity, wondering if this authenticity died somehow in transit, and if such structures are somehow more authentic at their point of origin; and then, in the grip of this notion, winging off to Tonga, with a pair of XXL swim fins in tow, to confront the very embodiment of Polynesian authority and authenticity, the King of Tonga, and finding him to be—*quelle surprise!*—a Valley guy! And once again, authority dissolves into mystery.

So, even though the Valley is the world in *The World of Jeffrey Vallance*, the essentials of Chandlerian narrative remain. When authority disappears, the effect is comic; the disappearance of any living creature, however, is ineffably tragic—and Blinky, the Friendly Hen has been *murdered*, served up in cellophane at a supermarket. Jeffrey Vallance discovers the corpse and rescues Blinky, much as Marlowe rescues Regan from the fate of being anonymously consumed. Vallance then buries Blinky in a pet cemetery and sets out to understand her fate. He is, like Marlowe, a relentless, loving agency with just a single "clue": the stained piece of cardboard upon which Blinky's carcass has been placed for display—the Shroud of Blinky. But this stained cardboard rings a bell; it reminds Vallance of the Shroud of Turin in which Christ's body was purportedly wrapped when he was lowered from the cross—and this, for Vallance, is enough to go on. The game is afoot!

Initially, Vallance moves outward from the death of Blinky into the mythology of birds and onward from the evidence of Blinky's shroud to Turin and its shroud, then on to Vienna, to Valley Forge, to Memphis and onward still from there, following leads, as a good detective should, observing closely, as an artist should, and making connections, like a master of the text. From the stain on Blinky's shroud Vallance is led to Turin. From the rent in the Shroud of Turin, he is led to the relics of the Holy Lance in Vienna. Through close examination of the enigmatic stains on Turin's shroud he discovers apocalyptic clowns, and, in the dried blood of Christ, he finds the profile of George Washington, which leads him back to the Book of Revelation, and onward to the mythology of America's patriarch. From the idea of sacred stains, Vallance is led to the Veil of Veronica, and then to the Vatican to reënact her miracle—but in hopes of what? Something, I dunno. It was just a hunch.

Then, transfixed by the strange fact that Elvis died on the toilet while reading a book about the Shroud of Turin, Vallance

heads for Memphis where he is able to establish a connection, via Veronica's Veil, between the sweat-stained scarves that Elvis distributed during his concerts and the Shroud of Turin, and then to the Shroud of Blinky, the Friendly Hen. It is all coming together now, and flying apart. It is circling inward toward the mystery of Blinky's death and rippling outward into the infinite complicity of human culture. It is pressing forward in cars and boats and planes across the face of the globe and plunging back-ward through pages of research into the muffled clangor of history. The front story is a jagged line across the globe; the back story is everything that ever happened. It is a mystery story. But it is no quest for resolution. It is a real mystery—about the whole world alive and resonating outward, like mighty bells, from the corpse of a chicken.

—Dave Hickey
Las Vegas, Nevada
April, 1994

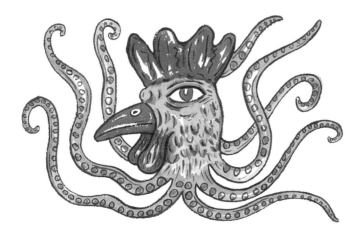

Blinky, the Friendly Hen

(dedicated to the billions of hens sacrificed each year for our consumption)

INTRODUCTION

On April 27, 1978, I went to the meat department at Ralph's super-market and looked at frozen chickens in plastic bags. I picked out a nice one and named it Blinky. Next, I drove to the Los Angeles Pet Cemetery to bury Blinky. At the cemetery office, I ordered the complete funeral service, which includes a powder-blue cas-ket with pink satin lining, a lot, internment, a flower vase, the viewing room, and a grave marker. By the time she got to the viewing room, Blinky was beginning to thaw, so she was placed on a paper towel so that moisture would not seep into the satin. A pillow was placed where Blinky's head would have been. A sub-tle spotlight shone on Blinky, and beads of moisture glistened in its beam.

At the grave site, artificial grass was placed over the dirt, and on this surface were placed the casket and the flower vase. To my surprise, when the coffin was brought out, my name instead of Blinky's was written on the lid; I felt as if I were wit-nessing my own funeral. The casket was lowered into the grave in the peaceful cemetery grounds, and the granite marker was set into place.

The mortician at the cemetery had only one question to ask me: "How did your pet die?" To this, I answered truthfully, "I don't know exactly how it died. One day, it just died." The ques-tion, however, planted a seed in my mind, which only recently came to fruition.

In 1988, on the tenth anniversary of Blinky's burial, I collaborated with video artists Bruce and Norman Yonemoto to make a videotape. The idea was to exhume the remains of Blinky and to use legal, medical, and scientific means to determine the cause of death. An autopsy was performed on Blinky, and her bones were analyzed by a computer. The symbols of death (the cemetery, the exhumation, the earthen grave, the corruption of the body, the putrid smell) were so strong that I could no longer think of the scene as dealing with the death of a mere chicken, but rather with the cold reality of all death.

BIRD-SPIRIT

After acting out this absurd drama, I discovered that the Blinky story follows classic folkloric/mythological/psychoanalytical logic. The bird, because of its ability to soar in the heavens, is associated symbolically with the spirit. In Christian iconography, the Holy Ghost is represented by a dove and the angels of heaven have wings. On the island kingdom of Tonga, the spirit of death is represented by the albino bat.

Ten years after she was buried, Blinky was exhumed, her bones washed and reburied. At the exhumation, there was one unforeseen problem. The water table was extremely high, and after digging only a few feet, liquid was reached: Blinky had been buried in a watery grave. Instead of a dry carcass, mud filled the casket to its lid. The bones had to be washed and sifted through a screen. This process seems to me now a reënactment of other processes, native to cultures far different from my own. In Madagascar, the ritual of the second burial is at the core of religious life. When a Malagasy dies, a preliminary burial takes place, and after a period of time, when it is judged that the dissolution of flesh and bones is complete, the deceased is exhumed. The remains are washed and wrapped in a fresh shroud *(lamha mena)*, and then reburied to complete the process of entombment. The ritual is known as "turning of the dead" *(Famadihana)*. The ultimate aim is to end up with clean, dry bones, which are subjected to the second burial. The polluting "wet" flesh is separated from the "dry" sacred bones. The flesh is thought of as female, the bones as male. It is believed that a snake

(fannina) is produced from the putrid fluids. During the Famadihana celebration, the remains are held, carried around, talked to, and danced with. In Malagasy cemeteries, cenotaphs, or standing monoliths, are erected; these are referred to as male stones *(vatolahy)*. It is believed that the dead who are subjected to a single burial will be transformed into bats.

CHARACTER OF POULTRY

Since the domestication of fowl, humans have closely observed the character of birds. We associate many barnyard attributes with our own nature. From the vigilant activity of the rooster come the terms "cocky," "cocksure," "cock of the walk," "cock-a-hoop," and "cockalorum." We like to think that when a cock crows, he is saying his own name: "cock-a-doodle-doo." From the timidity of the hen come the terms "chicken" (coward), "hen-peck," "chicken-livered," and "chicken-hearted." In Eastern Africa, a Wagogo man thinks that to eat the heart of a hen will make him timid. In a more profane vein, the slang term "chicken shit" denotes a worthless person. In the nineteen sixties, hot-rod artist Big Daddy Roth developed the character Chicken Shift, a drooling weirdo with flies buzzing around its head, its hand clutching the gearshift knob of a dragster. The chicken is also the object of ridicule and parody. A "cluck" is a stupid person. The joke-shop rubber chicken is thought to have slapstick appeal. The cartoon *Superchicken* presents a nerd-chicken who miraculously attains extraordinary powers. Closely related is the term "egghead," correlating the egg's ovoid shape with the bulbous head of a nerd-genius.

FOWL SEXUALITY

Descriptions of male and female human attributes have been derived from the sexuality of poultry. The egg is the female emblem for potentiality, conception, birth, renewal, immortality, and afterlife. The spring celebration of cyclic renewal and resurrection is represented by brightly colored Easter eggs. In Egyptian tombs, the hieroglyph of an egg floating over a mummy signifies afterlife. Maternity is represented by the mother hen sitting on a nest, incubating her eggs and in turn gathering her

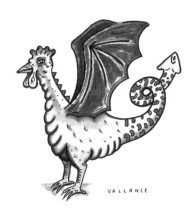

THE NAMING OF BLINKY

Blinky's name refers to the cockeyed
stare of the chicken. A chicken does
not have binocular vision, so it has to
cock its head to one side in order to
see objects on the ground.

THE SHROUD OF BLINKY

After Blinky was purchased at the
supermarket, I placed her on a piece
of paper for the purpose of photo-
documentation. Once lifted off the
paper, a perfect imprint in the blood
of Blinky remained. Thus was formed
the Shroud of Blinky. Like the Shroud
of Turin, the Blinky Shroud is a nega-
tive image that is scarcely visible in
sepia monochrome.

April 27th is the annual Feast
of the Shroud of Blinky.

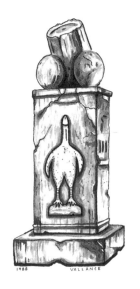

chicks under her wings. Cute baby chicks are symbols of the spring season. The term "chick" is used for a young, attractive girl. A young boy or girl who has been exploited sexually is called a "piece of chicken." In La Grange, Texas, there was a whorehouse called the Chicken Ranch, its logo a rooster kissing a chicken. An older man interested in having intercourse with young boys is referred to in certain circles as a "chicken hawk."

The cock (rooster) is an obvious male symbol, and the word "cock" has become synonymous with the penis, due to the resemblance of the wattles on the rooster's head to the human scrotum, especially in its proximity to the phallic beak. Another slang word for the male organ is "pecker," denoting the pecking action of the beak. In the Vatican's art collection is a celebrated bronze sculpture that has male genital organs placed on the head of a cock, supported by the neck and shoulders of a man. The Greek inscription on the pedestal reads, "The Savior of the World." In the Hellenistic temple of Dionysus at Delos is a monument in the form of a phallus. On the front façade is represented the bird-phallus, a roosting bird with the head of a penis. In contemporary sex-toy stores can be found a "tickler," a rubber condom with the head of a rooster at the end, its beak and coxcomb serving as the semen reservoir. The word "cocktail," meaning an alcoholic beverage, was formed by joining "cock" and "tail," slang terms for the penis and female sexual organs, respectively. The consumption of alcohol is regarded by some as a substitute for orgasm. Originally, the "cock pit" was an enclosed arena for cockfighting. In nautical vessels, it is the sunken space toward the stern used by seamen to steer. In the airplane, it is the space for the pilot. Cocktail bars located near airports are often called "The Cockpit." In foul language, the vulgar term "cockpit" refers to the vagina; pilots can sometimes be seen driving with bumper stickers that read, "Pilots do it in the cockpit." Another meaning for "cock" is the assuming of an erect or tilted position—such as the setting of the hammer of a gun into firing position.

The "coxcomb," or fleshy protuberance on the crown of a rooster's head, has also fascinated us. The aggressive and rebellious tendencies of the rooster are associated with the coxcomb;

in imitation of it, we find Mohawk hairdos and military helmets. Almost every culture has examples of the coxcomb shape: Romans, Hawaiians, Native Americans, Chinese, Mr. T, and punk rockers. The coxcomb resembles both a king's crown and its counterpart, the fool's cap. The red cap with notched cloth worn by jesters is called a coxcomb; from this usage, we still refer to a silly fellow as a coxcomb. American colonists wore a three-cornered hat called a "cocked hat." The practice has evolved into the "cockade," a knot or ribbon worn on a hat.

FOLKLORE

According to folkloric tradition, if a person takes an egg laid by a cock and places it under a toad or snake to incubate, out hatches a creature called a "cockatrice," which has the head, body, and feet of a cock, the wings of a bat, and the tongue and tail of a snake. Like Medusa, the cockatrice has the ability to annihilate by its glance; it can be hunted and killed only with the aid of a looking glass. In Isaiah 59:5, it is said of the wicked that "they hatch cockatrice eggs." In the Bible, the word "cockatrice" is sometimes translated as "adder" (*vipera berus*), a vile and venomous snake. The cockatrice, or "basilisk," is the heraldic symbol of Basel, Switzerland. A representation of Yahweh used by the ancient Hebrews and the Gnostic Christians was the image of a man with the head of a cock and twin serpents as legs. In Transylvania, among the Gypsies, if a woman gives birth to a boy, she is made to pass between the pieces of a cock which has been sacrificed and cut in two, or between pieces of a hen, if the child is a girl. Following this ceremony, the men eat the cock and the women eat the hen. This ritual is thought to cleanse the woman of disease and protect her from attacks by unclean spirits. On the island of Samoa, the kings are said to be descendants of the *moa* (chicken) clan. The island itself is named after a sacred preserve of fowl—*sa* means sacred and *moa* means hens; thus, "sacred hens." In Fijian mythology, the chief of all the fowl, Toatoatavaya-O (cock-a-doodle-doo), while looking for juicy worms on a reef, inadvertently placed his foot in the shell of a giant clam. The clam closed tight around his foot. When the high tide came in, the water rose over his head and he drowned.

Today, it is believed that is why the rooster crows and the hen cackles when the tide is rising.

The cock is the symbol of the corn-spirit. In parts of Germany, when the last corn stalk in the field is to be cut, the reapers bury a live cock in the ground up to its neck and strike off its head with a sickle. The cock is identified as a fertilizing power, which when killed rises to a fresh life in the spring. In America, the cock as corn-spirit can be seen as a logo on the box of Kellogg's Corn Flakes, crowing at a bowl of the cereal. In rural areas of Europe, the person who succeeds in grasping the last ear of corn harvested is called the "cock," and grain is thrown in front of him, at which time he must crow. Beer served at this festival is given the name "cock beer." Among the village peoples of Asia, if a woodsman fears that a tree he has felled is possessed by a spirit, he must cut off the head of a live hen on the stump of the tree with the very same axe he used to fell the tree.

Severing the head from the body is thought to release the spirit. This procedure is still practiced today in modern supermarkets. Consumers want to disassociate the meat they buy from dead animals.

A STORY OF SACRIFICE

The sacrificial stories of Christ (the Lamb of God) and of Blinky (the Friendly Hen) contain similar symbols. The lamb and the chicken are both domestic animals used for food and sacrificial rituals. Christ is the son of God; the cock is a sun sign. Christ was sacrificed for the sins of the world; Blinky was sacrificed for our consumption. St. Peter's cock crowed at the dawn of the Resurrection; in the barnyard, the cock crows at the dawn of the day. Christ compared himself to a hen when speaking about Jerusalem in Matthew 23:37: "How often would I have gathered thy children together, even as a hen gathereth her chickens under her wings." Christ was hung on a cross; Blinky was stuck on a supermarket shelf. Christ's body and blood are eaten at the Eucharist; chicken's flesh is eaten for supper. The head of Christ miraculously appeared on Veronica's veil; Blinky's head was severed. Christ was buried in a tomb; Blinky in a coffin. The image of Christ appears on the Shroud of Turin; Blinky's image appears

CHICKEN SEX CHANGE

It has been noted throughout history that poultry can have an abrupt sex change. In Basel, Switzerland, in 1474, a cock was accused of laying an egg. The cock and the egg were burned at the stake with "all the solemnity of a regular execution." In Germany, a superstition still exists that a crowing hen should be killed at once or its owner will suffer bad luck. In 1923, Mr. E. Nicholson of Brompton, England, stated that during the winter his hen laid eggs, but during the summer it sprouted the comb and wattles of a male bird, starting to crow and trying to mate with hens.

CHICKEN-ON-A-STICK

From the observation that a bird will perch on a high object comes the association of the bird (spirit) and the staff (a male symbol). The earliest recorded example of this image is found in the Paleolithic Lascaux cave paintings in France, which depict a bird on a pole. In America's Pacific Northwest, Native Americans carve a bird on the top rung of their totems. Throughout the United States, eagles are mounted on top of flagpoles. The heraldic coat of arms of Mexico shows an eagle on top of a cactus, with a snake in its talons. In Christian iconography, a bird is pictured on top of the tree of life or the cross. St. Francis of Assisi, Patron Saint of the Pet Cemetery, is often depicted preaching to the birds with a bird on his shoulder. At Kentucky Fried Chicken, we observe the white-bearded, fatherlike figure of Colonel Sanders, holding a staff and clothed all in white; above his head on a pole rotates a barrel of fried chicken. The cock that crowed three times at St. Peter's denial of Christ stands on a column, or some other architectural pedestal. The cock, as a symbol of the Resurrection, is invariably placed on the highest weather vane, tower, or cathedral dome. Currently, the image of a chicken-on-a-stick reëmerges in the guise of "country" design, which proliferates in the form of prefabricated, jigsaw-cut fake folk art—the wooden chicken mounted on a dowel.

on the Shroud of Blinky. Christ descended to hell; Blinky returned to the marketplace. Christ was resurrected; Blinky was exhumed.

At the conclusion of the videotape, Blinky's head is reattached, and her spirit travels up from the grave, like the triumphant ascension of Christ. But first she must return to her place of origin, the supermarket. Blinky is a product, and as her life flashes before her eyes, so does a maze of other consumer products. In the end, she is able to transcend the marketplace and enter heaven, where she is once again whole. R.I.P.

Los Angeles, California
April, 1978 and September, 1988

SOURCES

The Encircled Serpent, by M. Oldfield Howey
Erotism: Death and Sensuality, by Georges Bataille
Folklore in the Old Testament, by James George Frazer
Folklore and Psychoanalysis, by Paulo de Carvalho-Neto
The Fool and the Trickster, edited by Paul V.A. Williams
The Golden Bough, by James George Frazer
Madagascar: Island of the Ancestors, by John Mack
The Masks of God: Primitive Mythology, by Joseph Campbell
The Mythic Image, by Joseph Campbell
Myths and Legends of Fiji, by A.W. Reed and Inez Hames
The Sacred Hens, by Glen Wright
Sexual Symbolism, by Richard P. Knight and Thomas Wright
The Shroud of Turin, by Ian Wilson

Tonga, the Abode of Love

I found myself in a suit and tie sweltering in the tropical heat, standing on the steps of the Royal Palace at Nuku'alofa, Tonga. In a bag I held a pair of the world's largest swim fins, which I was about to present to the world's most gigantic king. I considered the chain of circumstances that led me here.

TONGA AND ITS KING

The Kingdom of Tonga consists of a chain of 170 islands, 36 of which are inhabited by a total population of less than 100,000. Tongatapu is the main island in the group, on which the capital city Nuku'alofa is located. The kingdom is located west of Tahiti and south of Samoa, bringing the chain near the international dateline.

Tongatapu is a classic example of a raised atoll. An atoll is a coral ring of small islands surrounding a lagoon, giving the appearance of a string of pearls. Tongatapu was once such a formation, until a geological event took place which thrust the island into the air, making the land completely flat.

Tonga's form of government is a constitutional monarchy. In Polynesia, before its discovery by Europeans, each island had its own monarch. One by one, the islands were colonized and governed by foreign countries until only Tonga was left with a ruling king. Tonga accomplished this great feat by building a royal palace and dressing its king to look like the King of England. When foreign ships arrived, they saw a palace, and

instead of a native chief, they were greeted by a proper-looking king. Tonga was left alone. That is why today many traditional Tongan customs and practices remain intact.

His majesty Taufa'ahau Tupou IV, King of Tonga, is greatly beloved by his subjects. His Majesty has a sharp wit and keen sense of humor, with a vast knowledge of world events. He has the personality of a benevolent grandfather rather than that of a reigning monarch. His Majesty, besides being his country's head of state, is a lawyer, author, anthropologist, sportsman, surfer, and musician. He is also accomplished in the art of the revered *fangugangu*, the Tongan nose-flute.

A LETTER FROM THE MAYOR

For a long time, I had wanted to have an audience with this one-of-a-kind potentate, but I knew I couldn't just walk in on His Majesty at the Royal Palace. Some kind of official introduction was needed.

I made an appointment at Los Angeles City Hall with my good friend Councilman Joel Wachs. In his office, I laid out my entire plan, detailing what I wanted to achieve in the Friendly Islands. Los Angeles Mayor Tom Bradley also agreed to write a letter of introduction, and asked me to convey his personal greetings to the king and queen. The king has come to Los Angeles many times on business, and has met with the mayor on several occasions. He considers Mr. Bradley his personal friend.

Before I left for the South Pacific, I asked a friend who had filmed a documentary about Tonga what would be the perfect gift to give the king. He said that while he was there, the king kept asking for large swim fins because his feet are so huge, and he couldn't easily get his size on the island. From a dive shop in the States I special-ordered the largest fins in the world: super-extra large.

TONGAN STUDIO

In Nuku'alofa, I took up residence along the beach front at the Fasi-moe-afi Guest House. One window of my room looked out onto the shore of the lagoon. There, each morning at sunrise, tractors and cranes would start dumping boulders into the sea

to create a new breakwater. More pandemonium I have never heard in my life. From my other window I could view the Hua-Hua Chinese Restaurant. The odor of fried rice would drift into my chamber, and occasionally one of the "Peking ducks" would squeeze under the fence and find its way under my window, where it would wheeze and quack almost inaudibly.

My studio was set up in a rented *fale*, or open-air hut. The shack was nestled amongst the tropical vegetation of an isolated area. The structure had no walls, so while I worked warm breezes carried the honey-sweet fragrance of blooming flowers into my nostrils.

THE SWIM TRUNKS INCIDENT

The day before my audience with the king, I was walking down the end of the wharf to go for a swim. Suddenly, a Belgian tourist ran up to me, excitedly screaming, "A man gave me a fish and children are going to dance in the park!" The Belgian wanted to take some home movies of the dancing, and asked me if I could help him with his camera equipment. I agreed and, carrying his camera bag, followed him to the town common.

On the grass near the band rotunda, children were assembling in long lines. They wore costumes in the Tongan national colors of red and white that looked like a cross between crepe-paper birthday cakes and Native American war bonnets. The children's *punake* (choreographer) became very excited when he learned that the Belgian was going to film the dance. He asked if we would please come along and shoot the entire festival.

The schoolchildren started marching down the street toward the palace. The choreographer asked the sentry at the gate if we might enter for the purpose of documenting the dance. The sentry said we could, on the condition that someone be assigned to prevent us from doing a taboo act. A girl named Hina (an older sister of three of the dancing children) was randomly chosen to be in charge of us.

Hina sat us down in front of the Royal Geese, who were huffing, honking, and craning their necks at all the commotion. We were directly in the king's line of vision. This was the first time I had seen the king in person. He was sitting in the door-

TAPA CLOTH

Tonga is one of the few remaining outposts for the production of tapa cloth, the traditional fabric of Polynesia. Tapa is made of the *tu tu* (mulberry) tree, and is a relatively pure and stable organic material. The dark brown *tongo* (dye) used for painting the tapa cloth is derived from the bark of the mangrove tree. The design on the tapa is called the *tapaingatu*, and the finished piece is called *Ngatu*.

In Polynesia there is no need to buy a paintbrush, because they can be picked from a tree for free! This native brush is called *fa*, and is the bristly nut pod of the pandanus palm.

To make my Tongan art, I wanted to only use materials that were indigenous to the island. To collect these substances, I went to Talamahu market, a group of stalls in the center of Nuku'alofa. I found a supply of tapa cloth lying atop a mountainous pile of watermelons. The *tongo* was stored in used beer bottles. I believe the lady who sold me the dye thought that I had no idea what it was for. She was sure I was going to end up drinking it.

WHERE FAT IS KING

In Tonga, body size is everything. Kings, chiefs, and nobles have always had mighty girths. As in Medieval Europe, today in Tonga obesity means that one is wealthy with an abundance of food, and does not have to work hard. Of course, the head of state has to be the largest of all. His countrymen like to keep him fat.

Traditionally, the Royal Family is of immense proportions. His Majesty the King stands 6 feet 3 inches tall with a mammoth torso, humongous head, hands the size of boxing gloves and truly king-size feet (his shoes are made by special order). The king is included in the *Guinness Book of World Records* as the fattest ruler on earth, with a titanic weight of 462 pounds. His mother, Queen Salote, stood a stately 6 feet 2 inches and was the symbol of motherhood for the island group.

Being rather stocky myself, I was at first a little embarrassed about walking down the streets of Nuku'alofa in my surfadelic swim trunks, until exotic native girls started gently stroking my calves, saying "You have such beautiful white legs." Chubby pale appendages are a highly prized anatomical feature, and I found myself unexpectedly in vogue. Tonga is a paradise for the overweight.

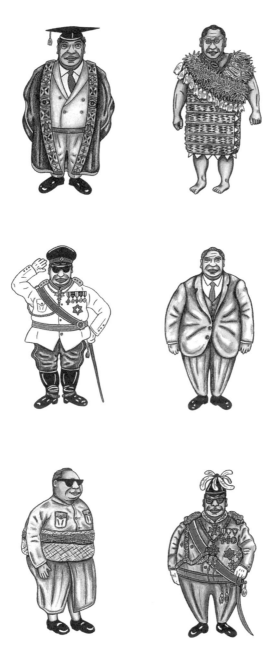

way of the Royal Palace wearing his oversized goggles (his trade-mark). He looked like a Buddha in a shrine. Piles of taro were heaped before him as an offering. Fattened porkers *(puka toho)* were laid out on the ground, hogtied and protesting.

The children started the movements of the *lakalaka*. It was an impressive sight, row after row of costumed children singing and performing the slow gestures of the intricate dance. After the dancing, the Tongan Police Brass Band began to play German marching tunes and an odd medley of songs. The only one I can remember distinctly was *How Much is that Doggie in the Window?*

While I was watching the ritual, I felt a stern tapping on my shoulder. I turned around to see a gargantuan Royal Guard clad in a very intimidating Green Beret uniform. He said, "Shorts are not permitted on the palace grounds." I immediately left the palace and ran across the *mala'e pangai* (polo field) adjacent to my hotel. I changed into pants, shirt, windbreaker, and street shoes, and took a taxi right up to the palace gates and through the crowds of onlookers, to make a triumphant reëntry. I realized later that I was the first person ever to wear swim trunks at the Royal Palace.

AUDIENCE WITH HIS MAJESTY

The day of my audience finally arrived. I carefully dressed in a suit and tie, and unpacked the giant swim fins and placed them in a black duffel bag. I called a taxi and, as I was boarding, out of the foliage appeared Hina. I had not expected to see her again, but I rationalized that maybe she thought she would always be in charge of me now. We piled into the taxi and proceeded to the Cafe Mozart. I had made a deal with Clemens, the pastry chef there, to photograph my audience with the king.

The three of us arrived at the office of Mr. Tongilava, Private Secretary to H.M. the King. In the waiting room, I viewed various important objects, one of which was the miniature Tongan flag that had been carried to the moon. Mr. Tongilava told me that I should address the king as "Your Majesty." When I asked him if I could have a photographer document the audience, he said, "No, the photographer may not attend."

At this point, a Royal Guard stepped through the door. He was the same man who had tapped me on the shoulder about my swim trunks the day before. With a warm smile on his face, he motioned that it was time to go to the palace. He looked closely at my nice suit and said, "The photographer may come." I believe that because of the swim trunks incident I had actually gained respect at the Royal Palace.

Clemens, Hina, and I were led to the palace portico where we awaited the arrival of the king. I thought the black bag looked ominous with the two heavy fins concealed within, and I asked the guard if he would like to inspect it. He said it would not be necessary.

Ten minutes later, I heard heavy, labored footsteps echoing throughout the palace. The guard said, "His Majesty awaits you." Hina stayed outside as Clemens and I entered the Royal Chamber. There he was, the KING OF TONGA, sitting on a massive wooden throne with the Tongan crest carved above his head. We bowed as we crossed the threshold. I said, "Greetings, Your Majesty. I have a letter from Mayor Tom Bradley of Los Angeles. The mayor sends his personal greeting and good wishes." The king said, "I like doing business in Los Angeles," but, he added, "L.A. is a concrete jungle." I replied, "I spend most of my time on the freeways." To that the king responded, "I never have to worry about getting lost in L.A., because I'm the king and somebody always drives me around." The king's voice had the resonance of a low metallic hum.

His Majesty is very sports-minded, so when I told him that I had taught an art class at UCLA, he asked me about the rivalry between USC and UCLA. He said, "The name of the USC team is the Trojans and the UCLA team is called the...?" I was supposed to say "Bruins," but my mind went blank and I quickly tried to change the subject. I told him I was working on a project using traditional Tongan materials. I showed him some examples of my work. I had to struggle against the breeze from his electric fan, which threatened to whip the artwork off the table.

When I finally pulled the flippers out of my black duffel bag, a broad smile appeared on His Majesty's face. He placed a boxing-glove size hand in the opening of the webbed rubber and

said, "I have a very hard time finding fins to fit my feet. These will fit nicely." Neither gold nor any precious gift could have pleased him more. After the presentation of the fins, the conversation became more relaxed.

As a gesture of friendship, I had brought along a collection of shells from the Louisiana Gulf of Mexico which I gave to the king. I explained that the shells were gathered by my 15-year-old pen pal, Dinky. I said, "The shells have no monetary value, but I know you have scientific interests in this area. Please accept these shells as a token of world peace." "Ah, some sea snails," said the king.

No time frame had been set for the audience. It seemed I could go on forever talking with him about any subject. When I looked around and saw the Royal Guard poking his head through the doorway, I thought it was time to bring the meeting to a conclusion. I said, "Thank you very much," and the king rose and gave me a hearty handshake. The Royal Guard entered and escorted us regally from the palace.

As we walked back into town, my body surged with life; I didn't even mind the heat of my heavy clothing. I felt exhilarated. I wanted to celebrate, so we returned to Cafe Mozart. Once inside, I ordered cakes and coffee for everyone. Hina was looking at a ring in a glass case, and I bought it for her. I was elated and would have bought anything for anyone. The ring had a deeper meaning for Hina, though. She thought it meant I would marry her. I tried to convince her otherwise, but it was of no use. She wanted me to live in her hut, but I cautiously agreed only to have dinner with her.

When the celebration was completed, I went back to the guest home and got out of the clinging suit and tie and changed into more appropriate tropical wear: swim trunks. I had carried the useless suit halfway across the world, and now that it had no further function, I gave it away to the first person I met on the street. I felt great. I had gotten rid of those ten-pound swim fins and the throw-away suit. I had met the king, which I thought was the greatest thing one could do in Tonga. I jumped in the pool and floated on my back, wallowing in a kind of weird ecstasy.

SACRED BATS

Tongatapu is inhabited by a curious flying mammal. The islanders call them flying foxes, but they are actually a large species of fruit bat. The bats live only in the causaria trees of a cemetery in the village of Kolovai. Although there are many similar clusters of trees, the bats choose to gather by the thousands only in this one village. The meat of the bat is highly prized as a delicacy, but it is taboo (sacred). Only the king can eat bat flesh.

I observed the bats for several hours to get an idea of their habits. They sleep during the day, curled up

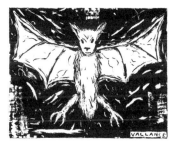

like stuffed grape leaves, hanging upside-down from branches. I noticed that while a certain bat was sleeping, its neighbor approached with a bony webbed finger and vigorously poked it in the back. When the slumbering creature awoke, both of them began to quarrel intensely.

There is a myth associated with the albino bat: Whenever a white bat is sighted, it means imminent death at the Royal Palace. In the midst of the bat-infested cemetery, there was the newly dug grave of a little girl. On the headstone was a ceramic portrait of the girl, and on either side of the stone stood little white plaster *putti* (angels). I couldn't help making the comparison between the white bat and the white-winged dove, symbol of the Christian Holy Ghost.

BAR SCENE

After witnessing many Tongan rituals, I decided that on October 31 (All Saints' Day), I would practice an American ritual: Halloween. I went to the market for a pumpkin, and to the trading post for a candle and a bowie knife. I went to a local Nuku'alofa bar down by the docks. The establishment was identified only by a sign that read: "BAR." It was for locals only. As I entered, some huge, rough-looking Tongans intent on playing a game of pool gave me menacing glances. The ruffians detected the bowie knife tucked under my belt, so the proprietor rushed up and confiscated the weapon.

I sat down and ordered a Foster's Lager. I explained that the knife was an instrument with which I would perform the custom of Halloween. Upon the return of the knife, I began to carve a jack-o'-lantern in the image of an ancient Tongan god. The pool-playing ceased and everyone began to gather around. One man served as an interpreter as I told the myth of Halloween. Others eagerly collected the leftover seeds and rind into a coconut shell and whisked it away. When the carving was finished and the candle lit, the lights of the bar were turned down and the patrons gazed at the foreign object in amazement. Later that night, I carried the glowing spectre down the pitch-dark streets of Nuku'alofa to the delight of squealing children.

POST-SABBATH MOVIES

Evidence of a strict Christian presence can be seen on Sundays in Tonga. For the entire Sabbath day, no work of any kind is allowed; this includes cooking, cleaning, and driving. All of the shops are closed and the streets are deserted, enveloped in a mood of calmness and serenity. But at one minute after midnight (Monday morning), all the shops open up and the streets fill with people laughing and drinking.

One such Monday morning, I joined in the festivities by watching a reggae film. (Polynesian peoples relate well to Jamaican culture because of their similar island heritage, habits, and foods.) At 2:00 a.m., the first film was over; I was about to go home when the second feature appeared on the screen. To my

WOOD CARVER

One of my chief goals in Tonga was to work with native craftsmen and musicians. The Tongan wood carvers were located in makeshift booths along the side of the road. It was ironic to find the carvers working not on their own Tongan designs, but making kitschy Hawaiian tikis for the tourist trade.

I proposed to one of the most serious and industrious craftsmen that he make a carving of my design from a sketch. The carver hesitated at first, because he believed that he needed royal permission to reproduce the likeness of the king—he was afraid that the graven image would rob the king of his soul. He finally agreed to collaborate on the piece if his identity remained a secret. For the next two weeks, I saw my collaborator walking around with my drawing folded into a wad in his front pocket.

When the moment of the unveiling arrived, I was taken to a private hut known only to the carver. The mood was somber as the object was delicately removed from its sack. To my surprise, the sculpture looked more like Fred Flintstone than His Majesty the King. I was greatly pleased.

TONGA A GO-GO

Tongan dancing is singular among Polynesians. Unlike the sensuous movements of Tahiti or the gyrating gestures of Hawaii, the Tongan solo dance *tu'a lunga* is quite conservative. The gestures of the *tu'a lunga* depict stories of Tongan life and love. The body movements are subtle, and the most curious motion is the swift jerking of the head, accentuated by a long feather. There is also the custom called *fakapale* (prize-giving). While a girl is dancing, people are encouraged to stick paper money to her well-oiled legs, shoulders, and arms, or place coins in her mouth. Young men use this device to show favor to the girl of their fancy. (*Fakapale* reminds me of a custom in the United States. At my local bar, the Batman A Go-Go, I have seen men clutching dollar bills lean toward the stage on which a topless girl is dancing. The dancer takes the bills and quickly tucks them into her bikini-bottom.)

I noticed that Tongan paper money is the most oily, dingy, wadded-up currency in the world. No wonder, when it is repeatedly plastered to the oiled bodies of dancing young virgins. If a bill is too dilapidated for use, one can take it to the National Treasury where a man in a booth reluctantly will hand out a fresh one. The Tongan paper currency is called *pa'anoa*.

consternation, the movie was *Valley Girl*. I had traveled halfway around the world to escape this kind of thing.

I watched the Tongans' reactions to this exotic culture with interest. After the show, when it was revealed that I was from the Valley, people questioned me extensively about the accuracy of the events they had just witnessed. I told them that Hollywood had got it all wrong. I explained, "The Valley is not really like that—it's more boring."

IN HINA'S HUT

The day arrived when Hina invited me to dinner on her island. From Fas-moe-afi we took a taxi to the end of the main island of Tongatupu. It was low tide and we waded across the isthmus to her island of Nukunukumoto. (Later, on the way back, it was high tide and I had to take a boat across.)

Hina's *fale* was of traditional Polynesian design with a thatched roof. The only piece of furniture was an old rusted Singer sewing machine with a plastic elephant perched on top. The walls were wallpapered with pages from a *Dick and Jane* book: "See Dick throw the ball, see Jane run." Hina made a savory dinner of eel cooked in coconut milk. As I ate, she asked me what kind of food I liked. I mentioned several things, one of which was chicken. She responded, "Chicken! Chicken!" I said, "No, that's all right, I've had enough to eat." Outside, I saw chickens casually pecking in the yard. Before I could stop her, one of them was stripped of its feathers and stuffed into a pot.

After dinner I took a nap. When I awoke, there was Hina, freshly bathed and wrapped in a towel. She was meticulously anointing her body with fragrant coconut oil. I looked around at the thatched roof and the geckos scurrying about, the sewing machine, the *Dick and Jane*s, the lagoon only a few feet away, and the palm trees swaying in the trade winds. For a moment I thought, "What would be wrong in marrying this South Sea Island girl?"

Nuku'alofa, Tonga
November, 1985

SOURCES

Art of the Pacific, by Brian Brake, James McNeish, and David Simmons

Shirley Baker and the King of Tonga, by Noël Ruther

The Happy Lagoons, by Jorgen Andersen-Rosendal

His Majesty King Taufa'ahau Tupou IV of the Kingdom of Tonga, by Amanaki Taulahi

Our Crowded Islands, by Epeli Hau'ofa

Tonga Island: William Mariner's Account, by John Martin

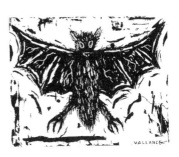

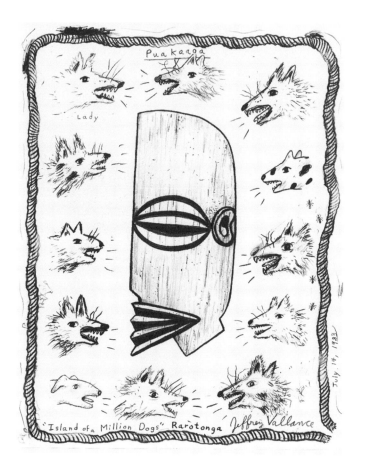

POLYNESIAN MYTH NO.1

Tiki, The First Man

Tiki was the first man.

It was said among our people that when Tiki was born, Atea himself set Tiki apart to bring forth all the children of men in this world below.

When Tiki was young his parents said to him, "You, Tiki, go outside and play," and they remained together inside the house.

One day when he was playing by himself, Tiki grew tired of the games he knew. He returned to the house and saw his parents at their own enjoyment. Tiki desired this. He therefore went away from the house and he heaped up earth in the form of a woman. He gave it a body and a head, with arms and legs, and breasts and ears and all that was required to make a woman. Having done this he acted in the manner of his father, and he there became a man.

Tiki took that woman for his wife, and her name was Hina, that is Earth Maid.

The child that was born to Hina was a human being, and they named her Tiaki-te-keukeu. She grew handsome. One day, Hina asked her husband to go to the world below to fetch some fire for them, for all the fires in that village had gone out. But Tiki was lazy and he refused, and so his wife said, "Then indeed I shall go myself to get us fire."

"No, no," said Tiki, "let us stay here quietly," and they argued thus; but Hina was strong in her will. She said to her husband, "You stay here. You have your daughter. I will go to the world beneath, as the moon goes."

And Hina went below. And she was swollen with child, like the moon. In the world below she gave birth to her twin sons Kuri and Kuro, who knew not their father.

Tiki remained in Havaiki with his daughter; yet it was not seemly that he should have her openly. He therefore built an inland house in a valley of that land, and he said to his daughter, "You live up there, and I shall live down here by the sea. Up there you will find the house that I have built and a man there who resembles me in every way. You will think it is Tiki, but you will be mistaken." So Tiaki-te-keukeu did as her father had told her; she went up the valley to that other house.

Now Tiki ran swiftly by another path, and he reached the house before her. When Tiaki arrived he greeted her saying, "Welcome, respected one. Enter this house of mine. Be seated on this mat." That girl did so. She went into the house, and Tiki desired her. He took her with his hands. She cried out, "No, I do not wish to. You are my father." And Tiki pressed her, saying, "It is true that your father and I are as alike as two drops of water, but he is down there by the sea. I am of the upland."

Soon that girl consented to live with Tiki in that house, and children were born to them. But after a time she became disgusted with her father, and she left him to seek her mother in the world below.

Her mother was disgusted also when her daughter told her, and they two made a plot to kill Tiki. They lit an oven in which to cook him, and sent the god Tuako up to fetch him. But Kuri and Kuro, the twin sons of Tiki, who knew not their father, made objection, and they prevented it. When Tuako went to the world-above he brought back a man named Katinga. It was Katinga whom they cooked and ate instead of Tiki.

While Tiki and his daughter were living together he told her one day that he was going out to catch fish. He asked her to follow him later with a basket for the fish. "You will come to the beach," he said, "and go to a place where you will see a flock of birds hovering about something which is sticking out of the sand. That will be the place."

And so Tiaki did as he had told her, she went to the beach with her fish basket. She saw the flock of birds and also something standing up above the sand. Thinking that it was their pointed stick for stringing fish, she took hold of it and pulled. And Tiki, who had covered his body with sand, jumped up crying, "Who's this pulling on my ure?" And he laughed at her shame.

When she saw that it was her father and that what she had in her hand was his, Tiaki reproached him: "O Tiki, this is a dreadful thing that you have done, a most horrible act of yours." And he laughed at her again; and she called him "Tiki the slimy," and "Tiki the rigid," and "Tiki the trickster." That is how Tiki earned those names of his.

After these events were known, the women of that land did not like Tiki. They called him "Tiki-god-of-kaikaia," meaning a person who eats human flesh or who sleeps with his relations.

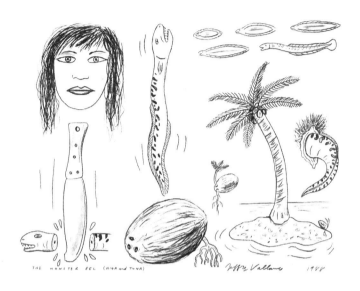

POLYNESIAN MYTH NO.2

Hina and the Eel

We speak of Hina and her love for Tuna, first of eels. From Tuna's
death we have the coconut, which bears his face.

Hina-moe-aitu, who was daughter to Kui-the-blind, lived in the
shadow of the inland cliff of the Makatea. Her house was near
where the cave Tautua has its opening. Now the water from Kui's
taro swamps disappeared beneath that cave into the Makatea, it
ran out to the sea beneath the land; and Hina's pool where she
washed herself was below that cliff.

In Hina's pool lived many eels; those tunas liked the darkness of
that pool. One day when she was bathing, an eel of great size
came from its place beneath the rocks, and startled Hina by its
pleasing touch; that eel went sliding under Hina in the place
where pleasure is. And the tuna was wicked, and the same thing
happened many times, and Hina permitted it. That eel gave Hina
pleasure with its tail.

One day while Hina was gazing at the eel it changed its shape, it
became a handsome young Mangaian. The young man said, "I
am Tuna, god of all the eels. It is because of your beauty that I
have left my home and come to you, O Hina, and I desire you to
have me."

So they did, they two; they went into Hina's house together, and
afterwards he always turned into an eel once more, so that no
person should know about them. Their love grew strong.

One day Tuna said to Hina, "I must go, I must leave you now for-
ever. Tomorrow there will be long-pouring rain, there will be

flooding rain, there will be rain from the rivers of the sky. The rain will fill this place, the water will rise until it covers all the taro beds; it will reach up to the door of this house; but do not be afraid, for then I will be able to swim here to your very threshold. I will lay my head on that threshold and you will know that it is I. Then quickly take the axe of your ancestor and cut off my head, bury it here upon the high ground. After that, be sure to visit the place each day, to see what will appear. Therefore Hina did as Tuna said.

Then the rains ceased and the floodwaters moved away, they passed out to the sea; and each day Hina visited the place where she had buried Tuna's head. For many days she saw nothing that grew, but then at last she saw a firm green shoot, it sprang up through the soil and it was not like anything that grew upon this land. Therefore Hina guarded that shoot, and on the next day she saw that it was two.

Those two green shoots sprang forth and Hina guarded them, and soon she had two fine strong trees that grew. After that time there were coconuts in this land.

These things were given to the land by Tuna the lover of Hina. Therefore we call the white flesh of the coconut *te roro o te Tuna*, "Tuna's brains." When all the husk is taken from a ripened nut the face of Hina's lover may be seen, the face of Tuna-god-of-eels, with his two small eyes and mouth.

Diet of Worms: I Joined the Samoan Police Force

Talofa!

DER WYRM

Once a year, a mysterious occurrence takes place on the island of Samoa: the arrival of the palolo worms. The palolo (*polychaete annelid*) is a rare and arcane creature with a transparent body that is green and wormlike. Similar to the habits of the California grunion, the palolo emerges annually from under the Samoan coral reefs. The palolos' appearance is determined by season, tide, temperature, and phase of the moon. Samoan chiefs and wise men try to determine the exact date and hour of their emergence. Strangely enough, my arrival in Samoa coincided exactly with that of the palolos. From my airplane window, I could see reflections of torch lights flickering on the waves, as fishermen attempted to gather up as many of the worms as possible, for they are a great gastronomic delicacy.

ARRIVAL

When landing in a tropical port, the last thing a weary traveler wants to do is waste time in a dingy travel agency. Sitting in an uncomfortable chair is how I spent my entire first day in Pago Pago, American Samoa. A tedious problem with an airline ticket had to be corrected right away. So there I sat in Samoa Tours and

Travel, with the coconut palms temptingly beckoning outside, until I met up with travel agent Joan G. Holland. To pass the time, Joan asked me various questions, and inquired about what I did for a living. When she heard I was an artist, she exclaimed, "An artist! We need an artist." Joan explained that she was looking for someone to illustrate books on Samoa and other projects. She asked me if I could please come live in her village of Leone, with free room and board in exchange for artwork.

LEONE VILLAGE

The tiny village of Leone is on the southeast side of Tutuila Island, built on the spot where John Williams (the first missionary to Samoa) landed. A beautiful whitewashed church, with a ceiling that looks like the upside-down hull of a schooner, stands in the center of the village. Leone Village is also home of the *Ali'i*, or Paramount High Chief.

High Chief Faiivae A. Galea'i, with his horn-rimmed glasses, looks more like an Ivy League graduate than a Polynesian chief. Chief Faiivae's hut hangs over the Punaloa Pond that was home of Princess Hina and the Eel, the site of the mythological origin of the coconut.

For my lodging, I was assigned the young men's quarters. Along with the rest of the residents, I was given a sleeping mat to lie on. A few exceptionally large toads lurked about and shared the accommodations. To make me feel at home, I was presented with a shopping bag full of groceries, the contents of which represented America's finest contributions to culture: Planters peanuts, Best Foods mayonnaise, Premium Saltine crackers, Pringles potato chips, Chef Boyardee Beefaroni, and a can of Spam. It was such a thoughtful gift, although I use none of the products at home. By consuming these U.S. exports, I felt as if I was in some kind of pseudo-hyper America in Samoa.

I expressed to the villagers my interest in their traditional Samoan cuisine. I had become acquainted with Polynesian food living in Tonga and the Cook Islands, but Samoa has a few peculiar dishes of its own. One evening, I was offered a special delicacy: smoked bat (*pe'a*) cooked in an earth oven (*umu*). The sinewy flesh of the bat tasted like dry, gamy beef jerky. (There is

not much meat on the bones.) The Samoan bat (also called the "flying fox"), as opposed to the unsavory cave-dwelling bat, is a tree inhabitant living on a healthy diet of tropical fruit.

At another dinner, a rare treat was served up: an abundant helping of palolo worms. The cooked palolo look like translucent green spaghetti-jello and taste like crunchy sea water. The morning after the meal, the villagers carefully looked me up and down and approvingly saw that I had survived the banquet. After that, each night for a week, I received a heaping plate of worms. European (*palangi*) stomachs usually don't fare so well; accordingly, I gained a little more respect in the eyes of the islanders.

In the men's lodge, I set up my Samoan art studio. My first project was to illustrate two books: *Samoan for the Visitor* and *Tariff Pago Pago.* Both volumes contained myths, legends, and landmarks which I was to illuminate. I was taken to the actual sites where, according to tradition, each story was believed to have taken place. I was working at a dizzying pace—no sooner had I finished the first project, than the whole village was alerted to my presence, and everybody wanted me to make something for them. Tapa cloth patterns were drawn, travel posters planned, needlepoint deigns (for a grandma) were laid out, and even a Samoan Christmas card was printed. It was nonstop art until the day I left; I felt like a Samoan art slave.

A POLICING FORCE

One rainy afternoon, I was approached by Chief Faiivae, who solemnly asked me if I wanted to join the Samoan Police Force— a rare opportunity I could not pass up. This offer was quite an honor, as only one other non-Samoan (an anthropologist) had ever served on the force. The duties of a Samoan police officer consist of hopping on the back of a pickup truck and driving around the village looking for loiterers, suspicious characters, and delinquent youths blasting rap music.

I was issued the official Leone Police Force uniform: a navy blue skirt (*lavalava*), white cotton shirt, flip-flops, and a combination flashlight/nightstick. With flashlights blazing, our patrol began at midnight, and entailed making several circumnavigations of Leone Village, broken up by a nap, then further

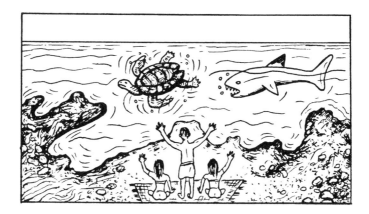

TURTLE AND SHARK

In the village of Vaitogi lived a blind lady and her granddaughter. There was a great famine in the land, so the girl and grandmother decided to commit suicide by jumping off the cliffs into the ocean. When they hit the water, the old lady turned into a turtle and the girl into a shark. Today tours are conducted of the Sanctuary of the Turtle and the Shark, where village priests chant a special invocation to make the turtle and shark appear. By some miracle, they usually surface, and if by chance they don't, the villagers are very disappointed.

GIANT PISI'S FOOT

A long time ago, a giant named Pisi lived in the land. The giant hobbled around on one gigantic foot. A family living nearby decided to kill the giant. They tried to push him off a cliff, but the harder they pushed the deeper his foot became embedded in the rocks. Pisi was victorious but his foot became stuck forever; his body deteriorated, leaving only his giant foot as a reminder.

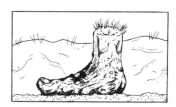

MYTH OF THE CANNIBAL SIAMESE TWINS
(adapted from the Samoan)

A long time ago there lived two girls, one named Taema and the other named Tilafaiga. Their father abandoned them as babies when he saw that they were Siamese twins. The twins were quite beautiful despite the fact that they were attached by shoulder, torso, and hips. They both longed to meet their father.

The King of Samoa heard that the twins wanted to find their father, so he gave them special permission to leave the island in search of him. His Majesty gave the twins a rare plant which is use to make dye; this plant is known as the lega root.

Because the girls were stuck together, they had to make a special canoe for their trip. They took a normal canoe and attached another board to it with a stick. One girl would lie in the canoe part and the other would lie on the plank. This was how the first outrigger was created.

Now, even though the girls were quite lovely, they had a serious character flaw. If people made rude comments about their appearance, they would kill and eat them!

They searched from island to island to try to find their father. Finally, they found him asleep in a hut with the blinds closed. At this spot, they planted the lega bush. The area where the Siamese twins rested is now known as Tapu-Tapu (Taboo) Point. To this very day, no one is allowed to pick the lega plant without permission from the High Chief. Woe to the person who tries to pick the lega root without permission, because some mysterious illness or misfortune will befall him!

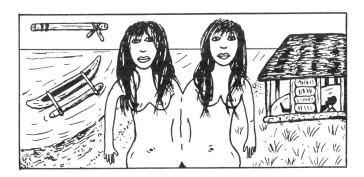

driving around. At nap time, I was issued a log with four little legs which would serve as a pillow. We officers would lie exposed outside in a neat row in the center of the village. The most memorable episode of my patrol was our discovery of scientists attempting to survey the cosmos—until we disturbed their delicate instruments.

A ROYAL FEAST

Near the end of my stay in Samoa, I was invited to a feast in the High Chief's ceremonial hut (*fale*), which was the most ornate structure on the island. The building, constructed on a raised platform (*paepae*), is roughly oval in shape. The roof is built of thatched palm fronds (*lau*) with moveable blinds (*pola*) on sides made of pleated palm leaves. The heavy beams (*utupoto*) are hewn of coconut wood and are held up by pillars (*pou*) ornately bound with sinnet (*'afa*), a coconut-fiber rope.

At the feast, the seating and serving order was determined by a strict and ancient code. On one side sits the *Ali'i*, and next to him are the lesser, or "talking chiefs" (*tulafale*), leading to the other side of the hut where the women and children reside. On this occasion, I was seated directly next to the High Chief. All the members of the village sat with legs crossed, but I could not assume this position for very long, so I finally shifted to a semi-reclining configuration—which was my fatal error. In a public meeting in the *fale*, it is taboo (*tapu*) to expose one's legs. One of the talking chiefs quickly threw a woven pandanus mat over my legs to make me more presentable.

During the feast, the *Ali'i* was served first and myself second. Laid out on a food mat (*laulau*) before me was an entire roast pig (*pua'a*), a chicken baked in taro leaves (*luaau moa*), breadfruit (*ula*), baked bananas (*fa'i tao*), taro (*talo*), papaya (*esi*), pineapple (*fala 'aina*), and my favorite, taro leaves cooked in coconut cream (*palusami*)—plus a few drinking nuts (*niu*) with several whole frosted cakes (*keke*). To honor the chief, I had to attempt to make a good dent in the servings. I realized, only after I ate, that the leftovers were to be taken to the rest of the village.

In Samoa, as in Tonga, rank and status are measured by abdomen girth. The High Chief was highly impressed by my

growing paunch. At the end of the feast, he reached over and rubbed my belly, saying, "You have a good start, but you have a long way to go before you become a chief."

Tofa!

Leone Village, American Samoa
November, 1985

SOURCES

The Book of Puka-Puka, by Robert Dean Frisbie
Cakes and Ale, by W. Somerset Maugham
Coming of Age in Samoa, by Margaret Mead
Crowds and Power, by Elias Canetti
Dangerous Marine Animals, by Bruce W. Halstead, M.D.
Eels, A Natural and Unnatural History, by Christopher Moriarty
Everyday Samoan, by E.A. Downs
Fine Art Slut, anonymous
His Majesty O'Keefe, by Lawrence Klingman and Gerald Green
Isles of the South Pacific, by Maurice Shadbolt and Olaf Ruhen
The King of Fassarai, by A.D. Divine
Kon-Tiki, by Thor Heyerdahl
The Legend of Te Tuna, by Richard Adams
Life at the Sea's Frontiers, by Richard Perry
Martin Luther the Lion-Headed Reformer, by J.A. Morrison
Nightcrawlers, by Charles Addams
Omoo, by Herman Melville
Power/Knowledge, by Michel Foucault
Reptiles and Amphibians, by Herbert S. Zim, Ph.D.
Samoan for the Visitor, by Joan G. Holland
The Savage Mind, by Claude Levi-Strauss
South Pacific Handbook, by David Stanley
South Sea Tales, by Jack London
In the South Seas, by Robert Louis Stevenson
Tariff Pago Pago, by Joan G. Holland
The Trial of Luther, by Daniel Oliver
Typee, by Herman Melville

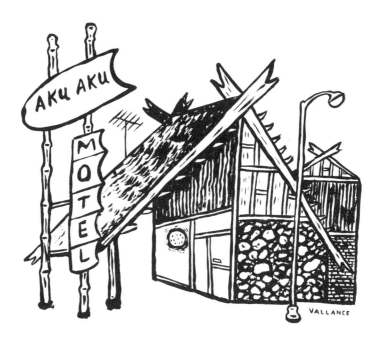

Avenue of the Absurd

LANDMARKS OF THE WEST SAN FERNANDO VALLEY

The San Fernando Valley has an ahistoric outlook. There have been some notable historic sites in the Valley—Indian villages, Spanish settlements, sprawling ranches and farmhouses—but one by one almost all have been destroyed. In the Valley, time seems to start in the nineteen fifties, when housing tracts began to multiply over the landscape. Instead of cultivating real history, the Valley creates fake history in the form of borrowed, historical-style architecture.

AKU AKU INN is named after Thor Heyerdahl's famous book in which the noted adventurer searched for the origins of the giant Easter Island heads. *Aku-Aku* means "guardian spirit" to the inhabitants. On this barren and isolated island, men of mystery built huge stone images, then disappeared. The motel includes 69 air-conditioned rooms, direct-dial phones, RCA color TV and hi-fi room music. (21830 Ventura Boulevard, Woodland Hills)

THE PLATT BUILDING is an example of "Valley Victorian" architecture. This edifice is the most ostentatious of the Valley's historical doodads. Included in the design are more than 1,000 artifacts from real Victorian-era structures. The exterior is brightly painted, and the windows are encrusted with gaudy stained glass. There is something discomfiting in seeing such a brand-new, old-fashioned dwelling, the whole essence of which is not dissimilar to a Farrell's Ice Cream Parlor. (19725 Sherman Way, Canoga Park)

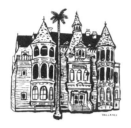

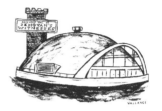

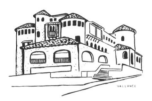

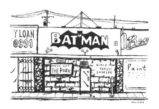

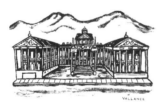

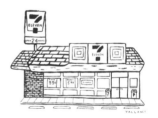

VALLEY ASSEMBLY HALL OF JEHOVAH'S WITNESSES is the best example of Valley modern architecture. This structure was originally constructed as an auditorium for secular concerts, shows, and exhibits, and was the first center of its kind in the Valley, built when architects still looked to the future with a sense of excitement. Now the building has been taken over by the Jehovah's Witnesses as an assembly hall. (20600 Ventura Boulevard, Woodland Hills)

THE DEL MORENO BUILDING is a Moorish castle/office building highly visible from the Ventura Freeway. Created in thick stucco, it abounds in turrets, archways, verandahs, and balustrades: Southern California Spanish-style architecture gone haywire. (Conveniently located just a few blocks east of the Chateau on Ventura Boulevard, which is fast becoming the Avenue of the Absurd, Woodland Hills)

THE BATMAN A GO-GO was constructed during the peak of the *Batman* TV show's popularity. The Batman, comfortably nestled in downtown Canoga Park, is truly one of the Valley's most exciting hot spots. Your evening begins with the throwing back of a couple of beers. Then, as if by magic, from out of a small, dingy booth, a dancing girl appears. She jiggles and gyrates to hits by Prince and Billy Idol. The highlight of the night occurs when men hand her dollar bills, which she quickly tucks into her bikini-bottom. Then, as you lean closer to the dance floor, if you're lucky she will drape her skirt over your head. This maneuver is called "The Veil of Ecstasy." (21516 Sherman Way, Canoga Park)

THE CHATEAU is an example of Valley neoclassical architecture. It is an exact replica of the Chateau Severne, built in France in the year 1789. (Ventura Boulevard between Winnetka and De Soto Avenues, Woodland Hills)

THE LOCAL 7-ELEVEN is the regional meeting place, watering hole and cultural center. In Paris, it's the cafes; in New York, it's the clubs; in L.A., it's Gorky's; but in the Valley, it's the local 7-Eleven. This fast-food establishment is a great common denominator;

sooner or later, every Valley resident ends up in one. The real swingin' thing to do is to park your car in front and hang out. Play a few video games. Have a Slurpee. (Various locations)

THE LOS ANGELES PET MEMORIAL PARK is one of Southern California's most distinctive landmarks. The cemetery, within easy access of the Ventura Freeway, is the final resting place of many of L.A.'s most beloved animals—many famous movie stars bury their dead pets there. Visit the cemetery on any holiday and see elaborate, festive decorations adorning the grave sites. Many pet owners bring still-living pets to enjoy the peaceful setting and romp on the lush, green grass. Among the Pet Cemetery's famous attractions is the tomb of Blinky, the Friendly Hen. (5068 Old Scandia Lane, Calabasas)

Canoga Park, California
September, 1985

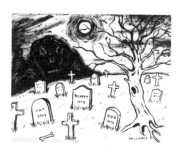

Iceland, Gateway to Hell

The land mass of Iceland became perceptible in the early light of dawn. The surface was barren and treeless. I had a sudden, desperate thought: What was I doing here?

BARREN LANDSCAPE

The first thing I noticed upon landing in Iceland was that there was not a single tree, not even a bush, growing anywhere. There was only the endless, barren volcanic earth strewn with boulders. Actually, there is some form of plant life, consisting of lichen and a very dry, short grass. The Icelanders have tried to plant trees, but they must build barricades around them because of the intense weather; those that survive barely reach the height of a man. Curiously, the most heavily wooded area I saw was the city graveyard.

There were no animals to be seen anywhere, either: no mammals, no reptiles, and hardly any insects. I found out later that all the animals the Icelanders do have—like cows, sheep, and horses—have been imported. Dogs are prohibited by law in most cities. There is also a lot of natural geothermal activity. Everywhere one looks there are pools of boiling gray mud.

A CLIMACTIC FESTIVAL

My arrival in Iceland's capital city, Reykjavik, coincided with some kind of yearly festival. There was a parade and a lot of long speeches. As I was not fluent in the Icelandic language, I understood little. The climax of the event was when a band of hooded henchmen dragged what looked like a corpse wearing a construction hat up onto a platform. I did not understand the

meaning of this, so I went into the audience to chase Icelandic girls dressed like Boy George.

I took up residence at the Reykjavik Salvation Army Guest House (actually a rest home for retired fishermen and the insane) and went for a walk. One must realize that at this time of year (May), the sun never really sets, so I went for a walk in full daylight at 10:30 p.m., wearing an overcoat in the freezing cold. One thing that is the same all over the world is the smell of the ocean.

REYKJAVIK COUNTRY WESTERN

I decided to sample the night life of Reykjavik, so I went out and had a hamburger at the Texas Snack Bar. Then off to the bar scene! I had a choice of the local pub or a disco bar. I went for the disco bar, and when I got inside, I found it was all done up in Western cowboy style. I felt like I was in Phoenix.

I talked to some attractive-looking people to find out what I should order. I was told that no beer is allowed in Iceland— that is, no real beer. Icelanders drink stuff that tastes like beer, but doesn't have any alcoholic content. Finally, they told me to order something that I couldn't pronounce, and the evening began to take on a grand manner. I met one of the locally bred beauties. Her name was Thora. She gave me her phone number.

Another evening, I decided to go out for a leisurely stroll. It was 9:30 at night and it looked like 2:00 in the afternoon. People were home from work, and I could hear them sitting down for supper, their dishes clanking and clattering. Someone in the next block was playing a lonely saxophone. There was a sleepy haze over Reykjavik.

I turned a corner and came upon a barrage of police cars. Police were holding back crowds of people. I heard gunshots ring out. The shots came from the old shipyard near the dock. Policemen were crouching, pistols drawn, behind all sorts of rusted boat rubbish. I joined the ranks of the growing crowd. The only English words I could make out were the constantly repeated phrase, "Free show." Bullets hit the gravel a few feet in front of me. After an hour or so, a wagon pulled up to the scene and the Reykjavik SWAT team, bearing high-powered rifles,

jumped into action. From the rubbish, the police dragged out what appeared to be a body wrapped in a blanket. They put it in an ambulance and drove off. I looked down the street. It was 11:00 p.m. and the sun was beginning to set. Steam was coming up through a crack in the earth.

PRESIDENTIAL PANDEMONIUM

Months before I came to Iceland, I started an exchange of cryptic letters with President Vigdis Finnbogadottir of the Republic of Iceland. (President Finnbogadottir was the first woman president of a democratic country.) In my letters, I told her that I would soon be coming to her country to make drawings about Iceland's culture, as well as its unique geographical features.

My plans were to meet with the president and show her what I was working on. The president's office is just a small building in the center of Reykjavik; it seems that just anyone can walk in—and that is exactly what I did. The day I went to her office, rain was slamming down hard, and I was wearing a big overcoat, and no hat. I came to the office sopping wet, and when I stepped through the door, everyone turned and gasped in amazement. President Finnbogadottir was walking down the hall holding some files, and for a moment she froze in her tracks. Then she scurried off to her office.

Right away, an official came up to me and asked me what I wanted. I said, "I have something to show the president." I reached into my soaking overcoat and pulled out my drawing pad. At this point, they became very concerned. I continued, "I would like to make an appointment with the president to show her my drawings." I was immediately ushered into the office of Halldor Reynisson, Secretary to the President.

I sat down in a small leather chair facing Reynisson's massive desk and opened my drawing pad, exposing drawings of wriggling, squirming serpents and Nordic gods. He looked at the drawings, then he looked at me, then he looked at the drawings again, then he looked at me and said dryly, "The president can see you next week." It seemed that she was very busy with important conferences. I said to Mr. Reynisson, "Next week I will not be in Iceland." That was the end of the interview.

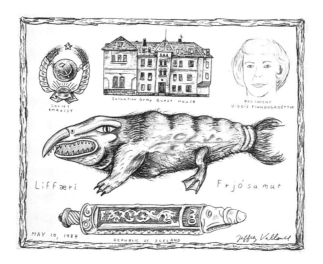

HELL'S VOLCANO

The volcanic Mt. Hekla, thought by some to be one of the gates of hell, looms snow and cloud-covered over the Icelandic landscape. Hekla is the root of the words "heck" and "heckle." All of Iceland is heated by geothermal water that is pumped up, boiling hot, from beneath the surface. The water has an odor of sulfur.

ICELANDIC WOMEN

Whatever hardships Iceland bears with its extremes of nature are counterbalanced by the extreme beauty of its women. I've never seen such clear complexions coupled with almost white-blonde hair. I don't know exactly what factors produce such nymphets, but they may be the most beautiful women in the world.

A POLYNESIAN CONNECTION

The main industry of Iceland is fishing, and that is about the only food they produce. However, during the few short months of summer, they cultivate a small, watery potato. My research in this area led me to the incredible Icelandic greenhouses, which are heated by the sun as well as with water pumped in from the hot springs. One particular greenhouse I stumbled into was filled with tropical plants. There were healthy banana trees with clumps of fruit, oranges, ferns, and even Norfolk pines. Some inventive Icelander had decorated this greenhouse with tiki masks and a coconut carved into the likeness of a monkey. In one corner there were Polynesian huts adorned inside with plaster Viking heads.

I had made a really good drawing of the president that I wanted her to see, so I decided to mail it to her. I went to the post office and bought all kinds of Icelandic postage stamps and affixed them all over the drawings (I wanted it to look like an official document). Then I asked if the postmaster would stamp the date right on the drawing. The woman at the counter took the drawing and went into the back room. I could see people huddled, their heads nodding, looking at my drawing and then stamping it. I stuck it in an envelope and mailed it off.

FRIENDLY SOVIETS

Feeling disappointed at not having been able to meet the president, I decided to visit the Soviet Embassy. The Soviets were as surprised by my visit as the president had been. Everywhere I looked, there were surveillance cameras and electrically operated doors. Nevertheless, we promptly made an appointment. I had to think of a reason for wanting this meeting, so I decided to talk about imports and exports.

The day of the appointment arrived. As I was getting ready in the Salvation Army Guest House, I couldn't decide whether or not I should bring my drawings, but at last I decided, What the heck. I went to the embassy and passed under the cameras and through the electric locks into a conference room.

Two men were there to meet me: one to talk about imports, and the other, exports. As we talked, I learned a few facts. The U.S.S.R. exports gasoline, timber, automobiles, matches, and vodka to Iceland. The export man said, "Cold country need strong drink." The import man said they import fish, wool, and paint from Iceland.

I asked a few more pertinent questions, then I pulled out my drawing pad. I was rather apprehensive about showing them my drawings, but I was glad I did. The drawings broke the ice, and both men were laughing and pointing at them. Finally, they asked me the reason I came to visit them. I said that I was an artist and wanted to know more about Iceland, and that I was writing a story. At the mention of the word, "story," they both sat up very stiffly and asked, "What story! What kind of story?" I said I was just writing a travel story to accompany my drawings. I

guess that explanation didn't sound too bad. They asked me where I was from. "Los Angeles," I replied. The subject of the Olympics came up. I was not sure if the Russians were going to attend the games. So, in the Soviet Embassy in Reykjavik, Iceland, I learned for the first time that the Soviet Union would not attend the 1984 Olympics.

MORE ICELANDIC RESEARCH

Now that my political work was done, I wanted to find some entertainment. I found that the film *Shōgun* was playing in town. I set out in the direction of the theater. I had always wanted to see *Shōgun*, but I haven't owned a TV for years. During the movie, streams of tears ran down my face. (It must have reminded me of something.) What was great about seeing this movie in Iceland was that every time any Japanese was spoken, there would be subtitles in English and then in Icelandic. It was like seeing Queequeg of Kokovoko stepping off the boat in Nantucket.

The next day I went to the National Museum to study ancient Icelandic artifacts. After looking at the Nordic gods and medieval wood carvings, I went outside to catch the bus back to the Guest House. I had no idea which bus to take, or even where it went, so I asked a gentleman standing at the bus stop. He was holding a catalogue from the museum, and it turned out that he was an artist too.

Gunnar Kristinsson is an abstract painter as well as a musician. His music is quite sophisticated. He plays a series of about 50 gongs of various shapes and sizes, assembled from the far corners of the world. He also makes his own instruments, constructed of coconuts, bamboo, and other cacophonic materials. The instruments I found most interesting were Icelandic tonal rocks that he played like drums.

Gunnar and I got to be friends quickly and he invited me to his farm in Thjorsardalur Valley, which is in the center of the island at the foot of Mt. Hekla. Actually, his farm is the last outpost before the edge of the huge lava field. On the farm, we ate a macrobiotic diet consisting only of grains. The meals were supplemented with thick, fresh unpasteurized milk, straight from

cows in the next building. I was confused the first time I went to an Icelandic dairy region. I saw the fields and could smell the unmistakable fragrance of cow, but there was not a cow to be seen. I learned later that for most of the year the cows never leave the barn because of the nasty weather.

When the day came to leave Iceland, I wasn't sure if I wanted to go or stay. There was still much to experience, but the climate makes doing anything difficult. Iceland is a country of extremes.

Reykjavik, Iceland
May, 1984

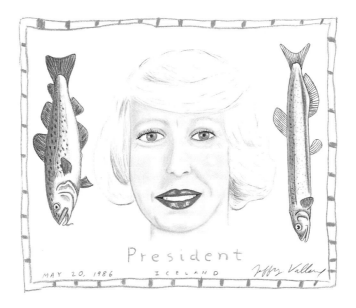

Fish Tales: My Meeting With Madam President

Greetings from Reykjavik!

I have been invited back to Iceland to have an exhibition at the Living Art Museum, which is the only contemporary art space in the country. I will be showing a series of drawings that I made in 1984 about Icelandic mythology and folklore. The show has been received quite well by the Icelanders. The work was reviewed in two Reykjavik newspapers, and I appeared on local television to talk about the show.

The people of Iceland are taught in school that their country has no artistic style of its own, so they look toward Europe and America for inspiration. People here are very excited about my work, because never before have they seen their own Icelandic symbols shown in this kind of context. I believe that through my work I have inspired many people to look at their own culture. What better gift do I have to offer!

On the bus ride from Keflavik Airport to the city of Reykjavik, I looked out the window to see the steaming, barren, volcanic landscape that once looked so unearthly and hostile to me. Now the same landscape appeared friendly and welcoming. This time, I thought, it makes all the sense in the world that I should be here.

FISH WOMEN

On my previous journey to Iceland, I asked this about the beauty of Icelandic women: "What factors have produced such nymphets?" On this expedition, I plan to search for an answer to that provocative question.

Iceland has the oldest form of democratic government in the world. Women have always had a strong role in Iceland, from the ancient sagas to the present time. Iceland elected the first woman president of a democratic country. More recently—and another first—women have achieved the majority in the Althing (Icelandic parliament).

In Icelandic folklore there has always been a peculiar relationship between women and fish (the country's two most valuable natural resources). There is a nursery rhyme that all the children sing in school which goes like this: "If I were a long and slippery-slimy eel, I would always curl myself around you." There are folk carvings of the same subject showing an eel curling itself around the head of a beautiful maiden. I was told that adults sing another version of the eel song which is more erotic—but no one would write down the exact lines for me. There is also a fisherman's tale that concludes: "If a man catches an exceptionally long fish, this means he will meet a beautiful girl." In countries that have no indigenous snakes, this archetypal image is represented by the next best thing: the eel. (There is a Polynesian myth called *Hina and the Eel* that bears a striking resemblance to Icelandic folklore.) The serpent of the Garden of Eden finds its way into many mythologies as a phallic animal.

In Iceland there is also a folk saying about the relationship between the beauty of a woman and processing fish: "It is good for a woman's complexion to work in a fish factory." Fish is Iceland's main industry, and this device is used to lure women to work in the factories. I am not sure if science has proven that processing fish is good for the skin, but certainly the consumption of fish is. Hence, the answer to my question is: FISH.

MEETING WITH MADAM PRESIDENT

In 1984, I tried unsuccessfully to meet Vigdis Finnbogadottir, President of Iceland. I did, however, meet Halldor Reynisson, Secretary to the President. Before I left for Iceland this time, I wrote Mr. Reynisson to request an appointment with the president. I hoped that the added credibility of my exhibition at the Living Art Museum would be the key I would need. When I arrived in Reykjavik, I called Halldor and he had already

arranged a date for an appointment with the president. On the phone, I asked him if I should come to his office to discuss what my meeting with the president would be about. He said, "I believe I know exactly what you are going to talk about." Which was odd, because I didn't even know what I was going to say.

President Vigdis Finnbogadottir is an unusual woman. She is a pacifist who is opposed to nuclear armaments. Before being elected president, she participated in a march against the U.S. Navy base in Iceland. Ms. Finnbogadottir is an unmarried single mother with an adopted child, and was the director of the Reykjavik Theater. She never intended to run for president until a housewife wrote a letter to the editor of a local newspaper suggesting she do so. President Vigdis is now the figurehead of Icelandic culture.

My appointment with President Vigdis was conducted in Forset Höll. I entered her office, introduced myself, and handed her an invitation to my exhibition. I showed her an example of an artwork that would be in the show; it was interesting to get a head of state's reaction to my work. She commented on illustrations of Icelandic mythology, a milk carton design, the Texas Snack Bar, and her office façade. She saw a portrait of herself and said, "I see you have included the Little Lady." At one point, we both walked over to the window of her office to gaze at the portico of a nearby bank, which I had drawn. She said, "It used to be such a wonderful classic bank made of Icelandic stone, until they built that ugly modern roof on it."

As a gift, I presented her with one of my ceramic cups with a snarling, scraggly dog painted on it. Vigdis struggled for a moment with the bubble-wrap encasing the cup. Then she removed it and held it in the palm of her hand, admiring the object. I could see that she was not reacting in the way one would to a token gift, but that she genuinely appreciated the cup. She said, "I am very touched by your gift. You know, I collect this sort of thing." She told me that she would display it in her office, and she placed it on her desk.

As an example of art criticism, I brought along an article by Peter Plagens from *Art in America*. (The article had a color reproduction of my work.) I showed it to the president and told

VOLCANO AND PUFFIN MEAT

The Westman Islands are a small chain of volcanically active islands south of Iceland. Surtsey, the youngest island in the world, emerged from the ocean depths on November 14, 1963. The fishing village on the main island of Heimaey was covered in lava by an eruption in 1973. Miraculously, no one was killed. On Heimaey, I visited the solidified wall of lava that had descended upon the village. Houses can still be seen half-buried in ash and pumice.

High on the volcanic cliffs of Heimaey, I observed puffins on their perches. The puffin is a penguinlike bird with a brightly colored beak similar to that of a parrot. It is curious to see the chubby puffins take off in flight. They jump off their precipices and fall straight down, like they are dive-bombing or committing suicide, until they reach the bottom and flap their little wings. Every time I saw one jump I felt a little queasy. Puffin hunters catch the cute little birds in butterfly nets. One evening for dinner, I was served a roasted puffin. Its flesh was dark black and tasted like liver.

MYSTERIOUS BOILING LAKE

Grindavik is a mysterious, thermally heated lake in Iceland. I went to this lake at midnight. As I approached, walking through jagged lava formations, the only thing I could see was a thick fog bank. Reaching its edge, I could perceive that the water was glowing a luminous blue. I took off my clothes and waded into the scalding liquid. My feet sunk into a sludgy muck, which was a brilliant white substance, much finer than sand.

Swimming in the lake is disorienting. After one gets a few feet from shore, it feels as if one is floating in a steaming void. People have become lost in the lake, unable find their way back. They become fatigued by the hot water and eventually drown. There are, however, a few small volcanic islands on the lake that one can crawl upon. I was very careful not to wade too far from shore.

The waters of Grindavik are thought to be a miracle cure for skin ailments. After my dip, I bumped into hooded skin patients wandering around the lava. They looked like a secret order of pagan worshippers.

her she need not read the article. She immediately held the paper closer and methodically began to read. Plagens' article used words like "folderol," "bozo," and "kidporn" to describe my work. When Madam President came to the line where my work was labeled "sexist," she looked up, gave me a quick glance and raised her eyebrow. I then said, "I would like to discuss the main reason for my visit..." (the president sat up very straight) "I believe that through the exchange of art, countries of the world can have a greater understanding of each other, and this can lead to world peace." She heartily agreed with me, and we discussed the topic for several minutes. President Finnbogadottir said, "Art is the best way to have one's culture understood. Also, it is good for industry. We can't just sell fish to a country, but if we give them a little art and culture, then they will buy the fish." A thought flashed through my mind of how fortunate I was to be able to make my statement to someone as important as a head of state.

The meeting concluded and Vigdis said she would certainly attend the exhibition. Afterward, as I was walking back to my studio, I panicked for a fraction of a second. It never occurred to me that she would actually see the show. The exhibit contained some not-so-flattering portraits of the president, along with off-color words in Icelandic.

NOISE AND MEAT

I set up my studio on the top floor of a three-story building that faced the town square. The former occupant of the space left it in a deplorable condition. This guy must have really been into meat. Inside the refrigerator I found molding and decaying hams, strings of sausages, and little bags of meat schnitzels. There was a lot of cleaning to do in the studio, but somehow I just couldn't bring myself to tackle the meat.

Across the street from my quarters was the main Reykjavik hangout bar. Every night at midnight (that's the time when the sun starts to set over the fjords, then immediately starts to climb back up into the sky), people gather at the bar. Reykjavik people are real party animals, and they do a lot of hooting and hollering.

Most nights I tolerated this party activity, but one night I wanted to get some sleep. I was having a hard enough time trying to sleep with all the daylight (there were no shades on my windows), but this night was exceptionally bad. People were laughing and screaming and drag-racing under my window. They were also doing this terrible thing where one person will honk their car horn, and then everyone else honks back in answer. I was lying in bed, my body getting tenser by the moment, hoping they would not beep again. Then it started: "HONK...honk, honk, honk." I jumped out of bed—I didn't know what to do. Then I thought of the meat. I ran to the refrigerator and grabbed a ham and tossed it out the window. Out flew strings of sausages. Bags of schnitzels plopped on the ground. Cuts of meat took wing.

I did it! I stopped the noise. Now I could sleep.

Reykjavik, Iceland
May, 1986

POSTSCRIPT:

Since my visit with President Vigdis Finnbogadottir, she has had two other visitors: U.S. President Ronald Reagan and Soviet Premier Mikhail Gorbachev. I was wondering if during the summit either one of them looked over and saw a cup with a snarling dog on it.

Desk Job

FROM THE DESK OF JEFFREY VALLANCE, HOUSTON, TEXAS

Dear Dinky,

Howdy from the Lone Star State! This letter comes directly to you from my office in downtown Houston. I'm in the city for three weeks doing an installation/performance called "Office" (similar to one I did in Los Angeles in 1985). It involves setting up an office—complete with desk, phone, typewriter, file cabinet, calculator, diplomas, water cooler, and Mr. Coffee. My paintings serve only as decoration. The public is welcome to make an appointment to discuss business, politics, economics, psychology, the aesthetics of art, or whatever. From my desk, through a large picture window, I have a view of a gray cement parking structure. Texas businessmen walk past my window and they seem to look at me approvingly, noticing that there is a new office in town.

 The idea for this piece came from two sources. First, I have always been fascinated by an attraction at Disneyland with recreations of two of Walt Disney's offices. Second, the Church of Scientology in Hollywood, California, has its founder L. Ron Hubbard's office preserved as a religious shrine.

Walt Disney's two offices, which he used for 26 years, were originally located in Burbank, California. One was his "working" office, and the other his "formal" office. The working office is of standard design, and this is where he did most of his business. The room is furnished with a black marble-topped desk, two tan

sofas, a black telephone, a trash can, a cork pencil holder, and eight identical glass ashtrays. One wall has a large aerial photo of Disneyland. A cache of mementos includes antique handguns, a walrus tusk, a shillelagh (cudgel), model airplanes, various paperweights, and Disney dolls. Even Walt's well-worn brown leather attaché case sits in the corner. The whole scene is so lovingly reconstructed that it includes the original wall thermostat.

The Disney formal office was used only a few minutes a day to entertain important guests. This room has an impressive oak desk, and displayed on a shelf behind it is Walt's famous miniature collection. The office is furnished with overstuffed chairs, a grand piano, a tan telephone, a globe, and a large bookcase filled with hundreds of volumes. Some of the titles represented include *At Home at the Zoo*, *The Alaska Book*, *The Face of Arizona*, and *Dali*. The memento department is stocked with Japanese dolls, a Greek bust, trophies, a small bird cage (which looks like he got it at Pic 'n' Save), and his children's bronzed baby shoes. On the wall is a photograph, and a portrait by Norman Rockwell of each of Walt's two daughters. A metal dog on the floor stands guard by the desk.

Every feature has been meticulously recreated, including the original carpeting, drapery, wall paneling, and even the electrical sockets and air conditioning vents. Each office has a lighted photomural of the San Fernando valley outside the "windows" (simulating the exact view Walt saw each day). In the two Disneyland displays, one real wall has been removed and replaced with glass and a few furnishings have been removed for better viewing. A brass guardrail has been constructed in front of the glass. I tried to get a complete list of everything in the offices, but a Disneyland official said that the list is strictly confidential.

L. Ron Hubbard's office is in the big blue Scientology headquarters in Hollywood. I ran across this office by accident. I wanted to see what was inside of the mysterious building, so I went in and a nice young man in a nautical uniform gave me a tour. As we were walking down a hallway, I noticed a gold plaque on a door labeled "L. Ron Hubbard." At this time no one had seen L. Ron for years, so I asked, "Is that really his office?" The

Scientologist replied, "This office is here and ready whenever Mr. Hubbard needs it. He can come in and start work any time." I looked in and whispered, "Has he actually ever been in?" The man hesitantly said, "No...but he can come at any time. The office represents his presence here."

Now that L. Ron Hubbard is dead, his office has been preserved as a memorial shrine. It is a typical-looking office, with wooden desk, chairs, lamp, feather quill pens, stapler, etc. He has a lighted globe exactly like Walt Disney's, except his has been turned on. Fresh flowers are placed on his desk as one would offer them at a holy site. The orange shag carpet is always recently vacuumed, leaving suction tracks. A portrait of Hubbard in a sailing cap smiles down upon the whole scene. A velvet cord stretches across the doorway, so his followers may look in, but not enter. It doesn't matter if L. Ron ever actually used this particular office, because to believers it represents the essence of his authority. It is a holy temple, a place of worship. Actually, each major Scientology building has such an office. The Hollywood complex alone has three L. Ron offices. In this way, the place of work has been sanctified.

My office in Houston also has all the traditional accouterments. Beyond that, I wanted to give it an insidious flavor. I accomplished this task by raiding local thrift stores, Woolworth's, and fire sale outlets. The Texas décor accents consist of a painting of a cowboy lassoing a calf, a pair of ceramic cowboy boots, a plastic cowboy statue, a "Texas Size" eraser, an oil-well pencil sharpener, a plaster armadillo (the State Animal), an Astros pennant, and the Lone Star flag.

I knew I needed oversized steer horns to top off the installation, but they were harder to come by than I had expected. I talked to the proprietor of Bubba's Bar-B-Q to let me borrow a set of horns. Bubba has about 20 pairs of mounted longhorns, and he serves several varieties of barbecued meat, which tastes like it has been mummified and soaked in grease for weeks.

I thought I was getting carried away with too many Texas souvenirs, but I was assured by the local population that many offices in the area have the same embellishments. My personal

mementos include a volcanic rock from Iceland, a seashell from
the Tuamou archipelago, a tiki from the Marquesas Islands, and
a framed desk photo of my Polynesian pen pal (a girl from the
Cook Islands). Kenneth Bianchi, the Hillside Strangler, once sent
away for phony psychology certificates and set up his own office.
I'm sure glad that I was not one of his patients.

From the city of Houston is hard to figure out. I am trying to find
something that is typically Texan. The downtown section has
many new postmodern skyscrapers. The only thing Western
about downtown is that after rush hour the city becomes a ghost
town. During the day, business people are rushing around. There
is traffic and no place to park. In the evening, there is not a soul
to be seen anywhere, only the moaning sound of the wind blow-
ing between the buildings.

From the window of my office one day I saw what I think
is the ultimate Texan. He is called "Boot Man." What distin-
guishes him from everyone else is that dangling from his shop-
ping cart are hundreds of cowboy boots. The boots are not for
sale—they are just for adornment. Boot Man lives under a bridge
where he has hundreds more boots piled in neat rows.

Since I began the "Office" performance, I have already had sev-
eral noteworthy appointments. Because I stated publicly that
people could come in and talk about any topic, I have received
many people with personal problems. A young girl came in and
tried to explain the problems she was having with her ex-
boyfriend. She said that he still comes around and tells her what
great sex he is having with his new girlfriend. She went into quite
some detail in this area. The lovelorn girl asked me, "Jeffrey,
what should I do?" I said, "Your ex-boyfriend sounds like a creep.
No one with any common decency would come over and talk like
that. He has no taste. Don't let him come over any more. You
don't need that."

An article appeared in the *Houston Post* about "Office"
which included my phone number here. This has had three
results. One is that now all the businessmen who walk by my
window come in. They cannot believe that such a plain-looking
office could be an art piece. They poke around and point at things

I have on display that they also have in their offices. When the gentlemen go back to their own offices, I hope they see their environment in a different light.

The second result is that the public has decided that I am Mr. Know-It-All. People are still calling me and asking all kinds of questions about sports, music, and business. And the third result is that I get crank and obscene calls. Heavy breathing (with a Texas drawl) and hang-ups are popular.

Other types of meetings I have had are with people who think that I am an office expert. A group of executives from McDonnell-Douglas Corporation asked questions about office design. A man in a very proper suit asked, "When creating an office, what direction should the desk face?" An engineer asked, "Please, can you describe the kind of chairs I should have in my new office?"

My favorite conference to date has been with an office interior designer. This woman designs only the most high-class executive offices. She told me that she uses the finest and most expensive materials, like marble and Italian woods. My office is furnished with the most inexpensive, tacky rubbish. When she first came in, she looked around with disdain. But as I explained the office, her expression softened. I noticed she was staring at a horrible electrical cord that was prominently attached to the front of my desk with uneven pieces of masking tape. I was seeing a woman transfixed in revelation. Her face was now in serene ecstasy.

The electrical cord had been a breakthrough for her. She said, "I finally figured out something. I don't need to use expensive materials or rare woods. You have created a mood here, something real, with only the cheapest materials. There is something to be learned here. Something I can use."

In doing research for my piece, I've learned that the institution of the office can take many forms: a gaudy amusement park attraction, a religious shrine, the desk of iniquity of a mass murderer, a source of knowledge, a work of art, and most importantly, a glorification of the source of the almighty dollar. It is the supreme symbol of the work ethic.

I have been in this damn office for almost two weeks now, and I have just about had it. How do business people work in places like this all their lives? I salute the office workers of the world for their tenacity in the face of excruciating boredom. Personally, I am used to working in the studio with paints and brushes and in my comfortable old clothes.

My office situation here is not the usual one, though. I am sitting in a picture window (I feel like I'm in a fish bowl) and my every movement is watched and scrutinized. I think I am ready for life in the studio again.

Please write and tell me what you are doing. I'd love to hear from you.

Sincerely,

Jeffrey Vallance

Houston, Texas
April, 1987

NOTE:

Dinky has been my pen pal since 1977. We met through an accident at the White House during the Jimmy Carter administration: I had written the President's daughter, Amy, and asked her for an autographed photo. In return, I received a postcard with a little picture of Amy on it. Another postcard had somehow become stuck to mine. It was addressed to a seven-year-old girl from Louisiana named Dinky. I sent Dinky her Amy Carter postcard, and I asked her if she would be my pen pal. She has been my faithful correspondent ever since.

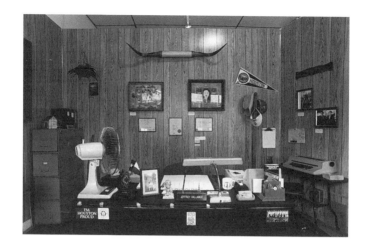

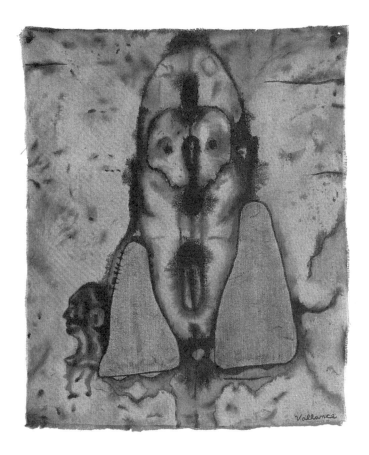

Veil Lance: Three's a Shroud

The dome of St. Peter's Basilica at the Vatican in Rome is supported by four massive columns. Each column is dedicated to the major Christian relic preserved inside: the Veil of Veronica, the Lance of Longinus, a particle of the True Cross, and the Skull of St. Andrew. Along with the Crypt of St. Peter, the objects in the columns can be seen as the literal and metaphoric support of the church. This account is about two of these relics—the lance and the veil.

THE HOLY LANCE

The Holy Lance, also known as the Spear of Destiny, *die Heilige Lanze*, the Spear of St. Maurice, the Romphea, *la Santa Lancia*, and the Lance of Longinus, is believed to be the instrument with which a Roman centurion pierced the side of Christ on the cross. "But one of the soldiers with a spear pierced His side and forthwith there came out blood and water." (John 19:34) At some murky point in history, a nail from the crucifixion was added to the lance, the center of the spear hollowed out and the Holy Nail inserted, but during this process the lance broke in two. The fracture was mended with an iron clamp, and the blade fastened with bands of wire which were in turn covered with sheaths of silver and gold. Two small knife blades, believed to be the ones used by Roman soldiers to divide the garment of Christ, were

added at the bottom of the shaft. With these additions, the sanctity of the Holy Lance was duly reinforced, but this also accounts for the rather complicated appearance of the lance today.

There are actually at least three Holy Lances, with somewhat different legends attached to them: *die Heilige Lanze* on display at the *Schatzkammer* (treasure chamber) in the Hofburg Palace, Vienna; the Lance of St. Helena, found while excavating Golgotha in Jerusalem; and the Lance of Phinehas, believed to be made by the grandson of Aaron, priest and brother of Moses. The Vatican also has its own lance in St. Peter's. To confuse matters further, over the centuries innumerable copies have been made at crucial points in history. Lance replicas have ended up in Nuremberg, Paris, London, Krakow, and Antioch, and each has at various times been confused with the original. The most recent documented copy was made for Emperor Franz Joseph of Austria in 1913.

The story of the Holy Lance is interwoven with history and legend, with fact and fiction. It seems as if someone has claimed that the Holy Lance was present at almost every significant event in history, even appearing at different places concurrently (through "bilocation"). Because the Holy Lance is one of the few objects believed to have penetrated God, and thus soaked with His blood, it has become an occult object. According to legend, whoever possesses the Holy Lance and understands the powers it serves, holds in his hands the destiny of the world, for good or for evil.

As in any legend, we begin at the dawn of time. We start with a man named Tubal-Cain, who was born to the seventh generation of Adam and the last generation of Cain, the world's first murderer. The story goes that Tubal-Cain prayed to God for a new metal with which to forge a mighty weapon. God immediately answered him by dropping a flaming meteorite nearby. Tubal-Cain used the meteoric iron to make a lance that would never rust and would always stay exceptionally sharp, but of course he left the "Mark of Cain" upon it. The lance passed through the hands of the Old Testament kings, including David and Solomon. The lance then somehow entered the line of Roman emperors, where Brutus jabbed it into Julius Caesar. In

Judea, King Herod skewered babies with the lance at the birth of Jesus. In Jerusalem, a Roman centurion named Gaius Cassius (Longinus) used the lance to wound the side of Christ. In Switzerland, St. Maurice and 6,000 Christian legionnaires were martyred, their blood flowing onto the lance, giving it additional sanctity. The Alpine ski resort of St. Moritz is named after Maurice; his relics are preserved in Turin, not far from the Holy Shroud. The lance was held by Constantine, Atilla the Hun, and Charlemagne. In England, King Arthur and the Knights of the Round Table possessed a mysterious bleeding lance. In Rome, the papacy preserved *la Santa Lancia* in a column at the Vatican.

Martin Luther was enraged by the veneration of the Holy Lance and started the Reformation. Lutheran mercenaries sacked Rome and desecrated the lance. The lance became part of the insignia of *das Heilige Romishe Reich Deutscher Nation* (the Holy Roman Empire), where it was carried into glorious battle. Napoleon tried to capture the lance and keep it at a distance from his forces, after which it was taken to Vienna. There it came into the possession of the Lords of the House of Hapsburg, where it was placed in the *Schatzkammer* of the Hofburg Palace. Adolf Hitler stole the lance and took it to Nuremberg where it became part of the Reich Treasure. After World War II, the U.S. Army reclaimed the lance. The lance was held by General George S. Patton, and soon after he died in a mysterious auto accident. The U.S. returned the lance to the *Schatzkammer* where it now rests in a vitrine on a dais of red velvet. (Or would you rather believe that Hitler had a Japanese Samurai swordmaker forge a duplicate lance, taking the original in a submarine, Indiana Jones-style, to Antarctica, were it was buried in an ice cave until rescued in 1979 by a secret society of Christians, the Knights of the Holy Lance.) The lance reportedly has been responsible for everything from the election of Ronald Reagan and the fall of the Berlin Wall, to the toppling of communism and the Gulf War.

SACRED STAIN SAGAS

The Veil of Veronica is one of three hallowed stain relics associated with Christianity; the others are the Holy Napkin, or Sudarium of Oviedo, and the famous Shroud of Turin, or *Sindone*,

THE SACK OF ROME

On May 6, 1527, Rome was sacked by a band of marauding Lutheran mercenaries inspired by the recent Reformation. Thousands of Romans were tortured and killed in the most unspeakable ways. Men were castrated, their genitals roasted like bratwurst which they were then forced to eat. Women were raped and killed at the moment of climax, then discarded in the street like sacks of rubbish. Helpless patients at the Catholic hospital were thrown into the Tiber river. The convents were attacked, the nuns forced into prostitution and sold on street corners. The churches were ransacked and looted, the Holy Relics were thrown in the mud and trampled underfoot (a scene similar to one I recently witnessed during the Los Angeles Riots of 1992). During this helter-skelter, the Veil of Veronica was passed from hand to hand throughout the taverns of Rome. The Holy Lance was stuck on the end of a stick by a looter, who then ran mockingly through the streets. The relics were scattered. After the Sack of Rome, there was some confusion as to the exact fate of the relics, with many different parties claiming the genuine articles. The Holy Relics developed the tendency to multiply themselves as Christ multiplied loaves and fishes.

CLOWNS AND SHROUDS

The Shroud of Turin contains the image of a tortured and crucified man, believed to be Jesus Christ. However, some people claim to have seen other images in the Shroud, such as chin bindings, Jewish phylactery packets on the forehead, and cryptic words and letters. Some researchers believe they see specific coins minted by Pontius Pilate placed over the eyes of the Shroud Man.

A group of secondary images caused by burn marks from a fire in 1532 produced what appear to be sinister clown faces on the shroud. Some believe that the devil tried to burn the Holy Shroud, but when this proved unsuccessful, he created the scorch marks (which are darker than the Holy Face) in an attempt to mock the shroud. People have also reported seeing symbols of death, resurrection, and procreation—including likenesses of owls, skulls, cocoons, atomic weapons, and male and female reproductive organs.

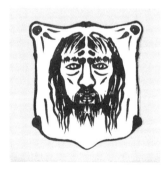

FEST DER HEILIGEN LANZE

A special ritual was instituted by
Pope Innocent VI, the *Fest der Heiligen
Lanze*. In the city in which the lance
was exhibited, garbage was cleaned
from the streets and a *Jahrmarkt*
(fair) was set up. In the presence of
the Holy Lance, people received
absolution. At the festival, rings were
touched to the Holy Lance and given
to people with pain in their sides,
producing blessed cures. Special
cloth was pierced by the lance six
times, and a document was written
confirming this procedure. Red wine
was poured into a chalice, and the
lance was thrust into it, making "Holy
Wine"—with wonderful stomachache-
curing powers. During this period, the
lance and its accompanying insignias
became equal in importance to the
Holy Relics of the saints.

SACRED ART

(from the Constitution on the Sacred
Liturgy, No. 122, Vatican II Document)

"Very rightly the fine arts are
considered to rank among the
noblest expressions of human genius.
This judgment applies especially
to religious art and to its highest
achievement, which is sacred art.
By their very nature, both of the latter
are related to God's boundless beauty,
for this is the reality which these
human efforts are trying to express
in some way. To the extent that these
works aim exclusively at turning
men's thoughts to God persuasively
and devoutly, they are dedicated to
God and to the cause of his greater
honor and glory.

"The objective of sacred art
is that all things set apart for use
in divine worship should be truly
worthy, becoming, and beautiful
signs and symbols of heavenly
realities. The Church has always
reserved the right to pass judgment
upon the arts, deciding which of the
works of artists are in accordance
with faith, piety, and cherished
traditional laws, and thereby suited
to sacred purposes."

believed to be the burial cloth of Christ. For centuries, the shroud was folded in such a way that only the face was clearly visible. Byzantine artists used the folded image as a schema for portraying the Holy Face of Jesus; this specific design has become almost synonymous with the veil image.

The Veil of Veronica is also known as the Holy Handkerchief, Sudarium (Holy Sweat Cloth), *Schweisstuch*, Mandylion (veil), and Holy Vernacle. The most popular legend states that the veil was created when a woman named Seraphina wiped the blood-tinged sweat from the face of Jesus as He carried the cross to Calvary. Afterwards, she looked at the cloth and a perfect likeness of Jesus was retained.

Another version claims that a girl named Veronica planned to have a portrait painted of Jesus, but when Jesus heard this He asked for the canvas, pressed it to His face, and gave it back to her with His image miraculously imprinted on it. According to another account, Veronica prayed to see the face of the Lord. One day, when she was leaving the temple, she met Jesus, who said to her, "Veronica, look now on the one you so wanted to see." Then Jesus took her cloak, pressed it to His face, leaving the impression of His features. A story from the *Acts of Thaddeus* states that Jesus wanted to wash His face, so a towel was given to Him. When He finished washing, His image was imprinted on the linen. And still another version from an independent Eastern tradition tells that Jesus imprinted His likeness on a cloth that He then gave to the king of Edessa. The name "Veronica" is derived from combining "Vera" and "Icon," meaning "true image." (In a similar vein, the bloodstained pillow and sheets of the assassinated President Abraham Lincoln are preserved in the basement of the Ford Theater in Washington, D.C.)

It is believed that the Veronica cloth was originally a longer fabric that was folded into three sections, transferring the image to each. The cloth was then cut into three parts. One part of the veil can be found at the Vatican, the second at the Duomo di Monsa near Milan, and the third in the Hofburg Palace, next to the Holy Lance. There is some controversy regarding the authenticity of the Viennese veil, some claiming that it is not the original but a facsimile made in 1617 by Pietro Strozzi, Secretary

to Pope Paul V. Other scholars argue that Strozzi only made the crude gold cut-out frame surrounding the veil image. In the Middle Ages, Veronica's Veil became the favorite subject of artists belonging to a special guild, *Pictores Veronicarum*, formed to duplicate the image. A practice evolved of touching a copy to the original, making the reproduction as holy as the relic itself. A seal was stamped on the copy, along with the signature of a canon signifying that it has contacted the original, and hence had become an object of piety. Over time, the copies became confused with the original. Throughout Europe, there are at least seven versions vying for authentication, including ones in the Church of St. Bartholomew of the Armenians in Genoa, the Church of Gesu in Rome, the Church of Manoppelli in Pescara, Italy, the Cathedral of Jaen, in southern Spain, the Convent of Santa Clara, near Alicante, Spain, the Cathedral of Leon in France, and the Matilda Chapel of the Vatican.

VEIL LANCE

It makes perfect sense to me that the lance and the veil can be found together in Vienna, home of Actionism, the Austrian art movement. While visiting the city, I had the rare opportunity to see, in a span of minutes, the lance, the veil, and the work of Rudolf Schwarzkogler, Günter Brus, and Hermann Nitsch, which were all within a few blocks of each other. I especially made a connection between the bloody face-print of Veronica's Veil and Nitsch's *Orgien Mysterien Theater* (blood relics). The lance and the veil, according to legend, were both products of the Passion of Christ. By the look of the blotchy, irregular bloodstains on the veil, it is either the first Abstract Expressionist painting (predating Yves Klein by about 2,000 years), or the first "performance relic" in history.

The Veil of Veronica was folded three times; the Holy Lance has three versions, each with a different lineage. While in Vienna, I decided to make three more copies of each object. I felt it was time. I chose to use the precedents and procedures set down through time; it was important to me to make these duplicates as close as possible to the originals (although I had to use some modern materials and technology in their manufacture).

APPOINTMENT AT THE VATICAN

On April 4, 1992, I had an appoint-
ment with Monsignor C. Sepe,
Secretariat of State Assessor at the
Pontifical Apostolic Palace in Cittá
del Vaticano. Several months before,
I had sent a drawing of the Veronica's
Veil I had made to His Holiness Pope
John Paul II, and received a letter in
reply from the Monsignor stating
that the Holy Father had gratefully
accepted the artwork into his personal
collection. On my pilgrimage to the
Vatican, the goal was to find out
exactly where the Pope kept my draw-
ing. Upon talking to the Secretariat, I
found out that the Holy Father has a
private repository where he stores

accepted gifts; the dispossession of the
objects are at the personal discretion
of His Holiness. The Pope can keep
the item I presented for himself or
present it as a sacred gift to any
Catholic congregation in the world.

On the same day as my appoint-
ment at the Vatican, I went shopping
in Rome for silk handkerchiefs, and
I ordered a double espresso coffee. I
then returned to the Vatican and stood
in St. Peter's Square, at the base of
the obelisk. In an attempt to recreate
the process in which the original
Veronica's Veil was created, I splashed
the espresso on my face and methodi-
cally pressed the handkerchiefs to my
skin to make artworks, each of which
I call a *Self-Portrait Sudarium*. After
my terse performance, I slipped into
the teeming crowds of St. Peter's.

By using the same dogmatic recipe in which the originals/copies were conceived, I hoped to create not crudely faked art, but truly sacred works of art.

Vienna, Austria
October, 1992

POSTSCRIPT: HOFBURG PALACE BURNS

On October 30, 1992, I performed the *Fest der Heiligen Lanze* at the Hofburg Palace, in Vienna's Josefsplatz, right at the base of the equestrian statue of Kaiser Joseph I. The ritual had not been performed for over 600 years. Standing at the foot of the statue, I began by carefully touching rings to the tip of the blade of the duplicate *Heilige Lanze.* (The rings were collected from the Vienna flea market, along with ones that were loaned to me by interested persons. I also used my own ring, the silver and ruby-encrusted Coronation Ring of the King of Tonga.) For the next step, I took out the special gray cloths and laid them on the marble base of the statue, and methodically began to penetrate the material with the blade of the lance, six times each. As I was stabbing the cloths, a group of tourists came and sat next to me. They began smoking and taking snapshots. I wondered how they could calmly sit there and ignore my maniacal use of such a menacing weapon. (Possibly the only documentary photographs of the performance exist as family photos with the Holy Lance somewhere in the background.)

For the next segment of the performance, I popped the cork on a fine bottle of Austrian wine. I poured the wine into an ornamental chalice, and thrust the lance into it; I then drank the Holy Libation. With the effects of the Holy Fermentation coming on, I arrived at the last act of the ritual, where the spear is held high aloft and a prayer is said. But first, I scanned Josefsplatz to make sure that the Royal Palace Guard was nowhere in the vicinity, as I was sure he would not think too highly of an inebriated man waving around a sharp, daggerlike object. So with eyes

closed, I held *die Heilige Lanze* aloft and said the Lord's Prayer in German (one of the few prayers I remembered from my Lutheran School days), thus completing the *Fest der Heiligen Lanze.*

While in Vienna, on November 20, 1992, I heard of the burning of Windsor Castle near London (more specifically, St. George's Banquet Hall—St. George being one of the purported owners of the Holy Lance). At the time, I remarked how, of course, the Hofburg Palace could never possibly burn. Just a few days later, however, on November 27, 1992, the Hofburg Palace did burn, and the buildings that were on fire were the ones directly around Josefsplatz, the very location I had chosen for my performance. The historic Redoutensaal Hall of the Hofburg burned, the site of the 1979 Strategic Arms Limitation Treaty signed by President Jimmy Carter and Soviet Leader Leonid Brezhnev. The newspapers printed photos of the equestrian statue of Joseph I, riding as if through the fires of Hades, with the Hofburg ablaze all around. I thought of how just a few days earlier, I had stood there holding the Holy Lance. It was actually the smoke alarm of the *Schatzkammer,* where the lance is preserved, that summoned the Vienna Fire Department. Luckily, the Holy Lance and Veil were unscathed! The treasure chamber received only minor water damage from the fire, and is now closed. I have in my collection burnt fragments of the Hofburg Palace from Josefsplatz; I keep these charred pieces as relics of the sorrowful fire.

Washington, D.C.
January, 1993

SOURCES

An Examination into the Antiquity of the Likeness of Our Blessed Lord, by Thomas Heaphy

Die Geschichte des Hauses am Ring, by Herbert Haupt

Die Heilige Lanze und das Schweisstuch der Veronika, Galerie Krinzinger, Vienna (catalogue)

Die Heilige Lanze, by A. Hofmeister

Hofburg: The Heart of Austria, by Christian Neuhold and Ed Handberg

Hofburg Vienna, by Peter Parenzan

Holy Faces, Secret Places, by Ian Wilson

The Kunsthistorische Museum Vienna: Schatzkammer and the Collection of Sculpture and Decorative Arts, by Manfred Leithe-Jasper and Rudolf Distelberger

Hermann Nitsch, Galerie Krinzinger, Vienna (catalogue)

Hermann Nitsch, Pabellón de las Artes, Seville (catalogue)

Die Reichs-Kleinodien, by Ernst Kubin

The Sack of Rome, by E.R. Chamberlin

The Secrets of the Holy Lance, by Howard A. Buechner

The Secular and Ecclesiastical Treasuries, Kunsthistorisches Museum, Vienna (catalogue)

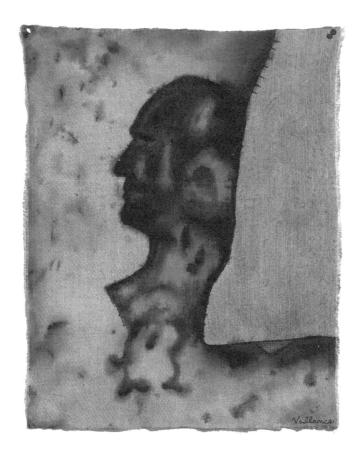

Prophetic Wound:
The Stain of Washington

Recently, a stain has been found on the Shroud of Turin that many believe is similar to the most famous image of U.S. President George Washington. Some patriotic Americans believe that the Washington image is a prophecy of the founding of God's Holy Nation—America. As evidence, they point to the profile on the U.S. 25-cent piece, which is almost identical to the stain on the shroud; further proof is that next to Washington on the coin are the words "In God We Trust."

The Washington profile stain on the Shroud of Turin was caused when the Roman centurion Gaius Cassius Longinus thrust his lance into the side of Christ as He hung crucified on the cross at Calvary, entering above the sixth rib and penetrating His heart. There are many remarkable similarities between the bloodstain and Washington's profile: first, the stain image has the same Roman nose as the president, as well as his sloping forehead, deep-set eyes, cheekbones, narrow lips, the dewlap of skin hanging under his chin, pronounced neck muscles, and the same colonial hairstyle worn in the late eighteenth century. When the image on the U.S. quarter-dollar is superimposed on the stain, the features line up exactly. The stain is an image of an older Washington, the way he looked at the end of his life—a kind of death mask.

In his book, *The True Likeness*, Dr. R.W. Hynek describes the lance stain as follows: "The blood was dark and thick, and it

at once coagulated on the chest, leaving in the imprints clear
patches formed by some colorless liquid. Now I myself have seen
similar thick blood, the colour of chocolate, issuing from the vein
of an unfortunate man who died under my eyes. The occurrence
took place during a journey through South America, when I was
visiting a friend, who was ship's doctor of the *S.S. Martha
Washington*."

GOD'S HOLY NATION

A veil of water concealed America from the Old World until God's
appointed hour. Our Puritan forefathers, seeking religious free-
dom, settled in New England and founded a nation based upon
the Holy Scriptures. A prophecy in Revelation 7:9 describes a
new nation that shall arise in a territory previously unoccupied,
and which will grow gradually and peacefully with peoples from
multitudes of nations and tongues. This new territory is believed
to be the New World, and the new nation the United States of
America. Many theologians believe that through Divine Prov-
idence, a kind of "Yankee Genesis" occurred, and America
became the New Israel. Forging a path in the wilderness,
Americans were God's new Chosen People. America, by the doc-
trine of Manifest Destiny and through the hand of God, became
a Holy Nation whose sacred documents are the Declaration of
Independence and the U.S. Constitution.

This New Israel needed a sacred leader, so God sent
George Washington as the American Moses. Through over-ven-
eration by his countrymen, Washington soon became the "Father
of His Country," and a transfiguration began that led to the apoth-
eosis, or deification of his image. Washington's glorification
progressed to the point of mass worship of his likeness. In 1830,
an associate of de Tocqueville wrote: "To Washington alone are
their busts, inscriptions, columns; this is because Washington in
America is not a man, but a God." Upon Washington's death, it is
believed that God's covenant was transplanted to the United
States. In death, Washington was like Moses, who never fully saw
the Promised Land.

Throughout the years, many scholars have tried desper-
ately to find references to George Washington in prophetic

manuscripts. In 1790, the writer David Austin systematically drove himself crazy trying to find Washington by studying Bible texts. The first Washington prophecy comes from Cicero (106-43 B.C.), the great Roman orator, who writes about a passage found in the *Sybilline Books*, a collection of ancient oracles: "Far across the Ocean, if we believe the Sybilline Books, there will be discovered a country large and rich, and in it will arise a man brave and wise who, by his counsel and arms, will free his country oppressed by slavery; and he will found under happy auspices a republic very similar to ours."

WASHINGTON'S PRAYER AT VALLEY FORGE

During the Revolutionary War, George Washington spent the severe winter of 1777 camped with his troops at Valley Forge, Pennsylvania. As his troops lay dying of hunger and disease, Washington, in his forest seclusion, knelt in the snow and prayed to the King of Kings, laying the cause of Liberty on the Throne of Grace. Then, on February 23, 1778, a mysterious spectre of a man rode into the camp at Valley Forge. This portly figure turned out to be Baron Frederich Wilhelm Augustin von Steuben, Canon of the Church of Prussia and aide to Frederick the Great. The King of Prussia sent the Baron to drill Washington's ragged Continental Army. By spring, the disorganized mob was transformed into a disciplined and effective military force.

At the same time, a miracle occurred that fed the starving soldiers. Next to the encampment at Valley Forge ran the little Schuylkill stream, and lo and behold there came an amazing spring run of fish called shad (*alosa sapidissima*), no doubt swimming upstream to answer an ancient instinct to spawn. There were countless thousands of shad arriving day and night for weeks (as in Luke 5:4-7), and the Continentals gorged themselves. Some of the soldiers did not believe that God had a hand in bringing the fish, but instead believed that a mythical bird, the "Yankee Bogle," led the shad upstream by squawking like an avian Pied Piper. By June, Washington's army, well-fed and drilled, marched to victory from Valley Forge, leaving behind the blood-soaked ground and the unmarked graves of the glorious dead who gave their lives for freedom.

SHROUD PREDICTS DOOMSDAY

Many fundamentalist Christians
believe that the end of the world—
the Day of Judgment—is near. Once
again, the Shroud of Turin is believed
to be a prophetic sign, revealing stain
images that can be viewed as thermo-
nuclear weapons, with bomblike
warheads and fins. Believers see the
George Washington stain as a sign
of America's manifest destiny as a
nuclear superpower and custodian
of the miraculous power of the Holy
Lance. The U.S. has 690 short-range
rockets in Europe—appropriately
named "Lance" missiles—that are
liquid-fueled projectiles with a range
of 80 miles. "The heavens shall pass
away with a great noise, and the
elements shall melt with fervent heat."
(2 Peter 3:10) The shroud predicts
Doomsday—The Armageddon of
Revelation 16:16-18.

QUEEQUEG WAS GEORGE WASHINGTON

In 1851, Herman Melville wrote *Moby
Dick*, considered by some scholars
as a modern sacred text. One of the
characters in his whaling story is a
Polynesian Islander named Queequeg,
from the isle of Kokovoko in the
Tongatapu Archipelago. Queequeg
was the son of a king, but left his
claim to the throne and traded in his
regal scepter for a whaling lance.
Melville describes Queequeg's
hideously tattooed face: "It may seem
ridiculous, but it reminded me of
General Washington's head, as seen
in the popular busts of him. It has
the same long, regularly graded
retreating slope from above the
brows, which were likewise very
projecting, like two long promontories
thickly wooded on top. Queequeg was
George Washington cannibalistically
developed."

WASHINGTON'S SWORD
OF PROVIDENCE

For George Washington, the sword was both a symbol of power and an actual military weapon. Even as a child, Washington is depicted holding a weapon: the hatchet used to cut down the mythical cherry tree. One of his swords, called the "Prussian Sword" or the "Sword of Providence" has a legacy of its own. First given to Washington by the legendary Frederick the Great, King of Prussia (1712–1786, not to be confused with Frederick II, 1194–1250, Holy Roman Emperor and owner of the Holy Lance), the sword was forged by Prussian armorer Theophilus Alte, who sent his son to personally present it to President Washington. For some unknown reason, Alte's son pawned the sword for a few dollars at an American tavern, but somehow through the intercession of one of Washington's friends, the saber finally reached the hands of the First President.

On October 16, 1859, when George Washington's great grand-nephew was captured and held hostage at Harper's Ferry, the Sword of Providence was confiscated and gloriously worn by John Brown during his famous raid. Thus, the sword ushered in the start of the American Civil War. (The Prussian Sword is now preserved in the Washington Museum at Mt. Vernon, Virginia.)

WASHINGTON AND LONGINUS

It is said that the statue of Washington in the Richmond State Capitol, made by Jean-Antoine Houdon, is the greatest statue of Washington ever made. The Houdon masterpiece captures the moment of Washington's return to his Mt. Vernon farm, after leaving the office of president. Washington stands fossilized in mid-transformation from soldier to farmer, doing a kind of "spiritual striptease," as he throws down his cloak and hangs up his sword. At the same moment, he takes up his Virginia planter's walking stick and returns to the plow. Like the ancient legend of Cincinnatus, the Roman called from his plow to save Rome, farmer Washington is solidified in that republican metamorphosis from sword to plow, from war to peace. ("And they shall beat their swords into plowshares." Isaiah 2:4)

A comparison can be made between Houdon's statue of Washington, and Gian Lorenzo Bernini's 1628 sculpture of St. Longinus (the Roman centurion whose lance pierced the side of Christ on the cross). Bernini's marble Longinus is shown in dramatic emotion, at the precise moment of his conversion from soldier to Christian. The centurion firmly grasps the Holy Lance, and at his feet are thrown his helmet and armor. The saint is transfixed in a vision, and as he looks upward to the crucified Christ he exclaims: "Truly, He was the Son of God." (Mark 15:39) This line was made immortal by John Wayne playing the role of Longinus in the film *The Greatest Story Ever Told*.

NAPOLEON VS. WASHINGTON

Two great revolutionary generals, Napoleon and Washington, each had the dream of a revived Roman Republic—one in the Old World, and one in the New World. Recently, in Memphis, Tennessee, an exhibition of Napoleon Bonaparte's personal effects were on display. (The Napoleon exhibit was not far from Graceland, where Elvis once donned Napoleonic jumpsuits.) Napoleon seriously respected Washington, whose bust once adorned his private study.

Napoleon dreamed of capturing the Holy Lance, but this obsession would never be fulfilled. It was not deemed by Prov-

ELVIS SHROUD

On December 21, 1970, Elvis Presley (clad in a purple crushed-velvet suit, with high Napoleonic collar and cape) stayed in the Washington Hotel (room 506) in Washington, D.C., before he was to meet with President Richard M. Nixon. At the White House, Nixon awarded Elvis with a Narcotics Agent badge and appointed the heavily stoned King of Rock 'n' Roll a Special Agent of the Bureau of Narcotics and Dangerous Drugs. In return, Elvis presented President Nixon with a commemorative Colt .45, which is now preserved at the Richard M. Nixon Library and Birthplace in Yorba Linda, California.

During his final performances, Elvis distributed sweatcloths to his fanatical followers—everyone wanted a piece of the King. Elvis would take one of his dozens of brightly colored scarves, position it around his neck for a few seconds—just enough time to soak in a small portion of sweat—and then cast these products repeatedly into the audience, in a climactic ceremony suggestive of the distribution of the Holy Eucharist.

Elvis died sitting on the toilet, while reading a book on the Shroud of Turin; his body was found in a fetal position in his bathroom, with the book lying by his side. After an exhaustive three-hour autopsy, the corpse of Elvis Aaron Presley was wrapped in a paper shroud. (The whereabouts of the Elvis Shroud have yet to be discovered; some believe it is in a private collection.)

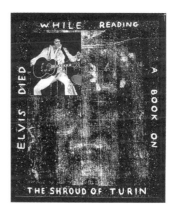

idence that Napoleon attain the lance, as the blood on the Holy Shroud congealed into the profile of Washington, not Napoleon. The Holy Lance, along with three nails from the crucifixion, were found in Jerusalem by St. Helena, mother of Constantine. One of the Holy Nails was set into the center of the Holy Lance; the second can be found in a reliquary in the Hofburg Palace, Vienna; and the third nail was attached to the Iron Crown of Lombardy, used in the coronation of Charlemagne, and preserved in the Duomo of Monza near Milan. In Milan, on May 26, 1805, Napoleon wore the Lombardy crown and proclaimed himself King of Italy. Later, he was exiled to the island of St. Helena.

IMAGE OF WASHINGTON

Washington is a blank slate; not much is known about his real personality. He stands cold and aloof, like a statue. But Americans see Washington in total perfection—they evoke the myth of Washington as they worship his shrines, icons, and relics, evolving holy ceremonies and rituals. Hundreds of thousands of pilgrims venture each year to the major Washington shrines: his home at Mt. Vernon, and the Valley Forge encampment. He lives today in the heart of every red-blooded American, and will endure forever!

Milan, Italy
October, 1993

SOURCES

The Age of Napoleon, by J. Christopher Herold

America in Prophecy, by E.G. White

The Apotheosis of George Washington, by Patricia A. Anderson

Bernini, by Howard Hibbard

The Call of Destiny, by Hamilton Paul Traub

Call Me Ishmael, by Charles Olson

Cincinnatus, by Garry Wills

From Sea to Shining Sea, by David Manuel and Peter Marshall

General Washington and the Jack Ass, by Thomas Yoseloff

The Invention of George Washington, by Paul K. Longmore

Iroquois Indian Dance, by George Washington

Journal of Major George Washington, by George Washington

A Life of George Washington, by Francis Glass

The Life of General Washington, by Mason L. Weems

The Life Portraits of Washington, by M. Fielding and J.H. Morgan

The Light and the Glory, by David Manuel and Peter Marshall

Moby Dick, by Herman Melville

Mount Vernon: The Story of a Shrine, by Gerald W. Johnson

New Essays on Moby Dick, edited by Richard H. Brodhead

Rules of Civility, by George Washington

The Seven Ages of Washington, by Owen Wister

The Spear of Destiny, by Trevor Ravenscroft

Storm-Troopers of Satan, by Michael Fitzgerald

The True Likeness, by Dr. R.W. Hynek

The United States and Britain in Prophecy, by Herbert W. Armstrong

Valley Forge, by Donald Barr Chidsey

George Washington, by Richard M. Ketchum

George Washington: The Image and the Man, by W.E. Woodward

George Washington: The Making of an American Symbol, by Barry Schwartz

Washington Walked Here, by Mollie Somerville

Weapons of the American Revolution, by Warren Moore

White Jacket, by Herman Melville

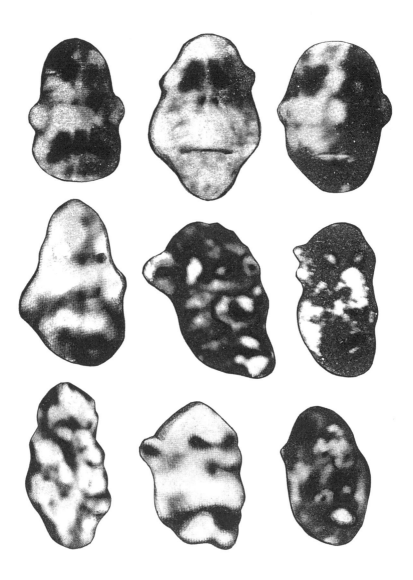

Searching for Bigfoot
in the Eye of the Guadalupe

PARANORMAL OREGON

Recently, I have taken up residence in the Pacific Northwest. Upon my arrival at the Portland, Oregon airport, I was greeted with the slogan, "Welcome to Sasquatch Country"—which gave me the idea to search for Bigfoot. I started my research by purchasing a six-pack of Bigfoot Beer from the local liquor store, and then picking up the phone and ordering a Bigfoot pizza from Pizza Hut (huge, but tasteless).

As I combed through my research material, I planned my Bigfoot expedition. I had seen plaster casts of Bigfoot prints on sale for $125 at a junk shop in Seattle, but I figured I could make some just as good in the backyard. I heard of several sightings of Bigfoot on nearby Mt. Hood, so I jumped into my 1971 Pontiac Firebird 350 (the firebird, or phoenix, is a Christian emblem for resurrection). Driving down Highway 26, I soon spotted the Bigfoot Lodge in Sandy, Oregon. The lodge is a dilapidated road-side motel with a cheap plastic sign out front beckoning the weary traveler to rest. I pulled up and went straight into the office. I rang the bell and a fat lady, wearing a dirty T-shirt and

missing a few teeth, came to the desk. I asked if she had ever seen Bigfoot. She answered, "No! I just work here." The only shred of information I could glean from her was that someday they'd like to commission somebody to make a Bigfoot statue to put out front by the sign. In my mind I pictured one of those rustic chain-saw carvings, hewn out of a huge log.

OREGON MARIAN APPARITION

At about the same time, news of an Oregon Marian apparition came to my attention. In the town of Boardman in the Columbia River Valley, the image of Our Lady of Guadalupe became visible as a corporeal vision, or three-dimensional entity. Our Lady appeared in a leaky trailer belonging to Irma Muñoz. The Virgin was momentarily incorporated into a desert-landscape painting Irma had recently acquired from a garage sale. Irma first saw the supernatural manifestation of the Virgin while she was watching MTV.

Irma could tell that the theophany (direct appearance of a Heavenly Being) in front of her was the *Virgen de Guadalupe*, because she recognized the classic tilt of the head and the praying posture. The image was in the shape of an oval (*visica*), showing a full-length Madonna surrounded by a halo, or aureole. This apparition is seen by some as a proximate sign—one that precedes the Second Coming. A pilgrim to Boardman was heard to ecstatically proclaim, "The Finish is coming. The End!" This image of the Blessed Virgin Mary is exactly like the manifestation which appeared in Mexico City in 1531. The Guadalupe's appearance in Boardman occurred smack in-between two Bigfoot sightings—one at Hood River, and the other in the Umatilla National Forest. The Columbia River Gorge is known as a paranormal hot spot, where many unexplained sightings and footprints have been found.

CRAWLING TO THE VIRGIN

As part of my research, I made a pilgrimage to Mexico City—to the Basilica de Guadalupe, where the spontaneous image of the Blessed Virgin is preserved. The image was generated in 1531 when Juan Diego, after seeing a Marian apparition, asked for a

heavenly sign from God. Our Lady directed Juan to pick some Castilian roses that miraculously appeared on Tepeyac Hill. ("The desert shall rejoice, and blossom as the rose." Isaiah 35:1) Juan wrapped the roses in the front of his poncho (*tilma*), and brought them to the bishop. When Juan's coat was unfurled, a photographic stain-image of the Queen of Heaven developed before their very eyes. The image, painted as if by God, materialized on the humble garment.

A basilica was built on the site, which now attracts thousands of pilgrims each year. As I approached Guadalupe Plaza, I saw throngs of worshipping pilgrims crawling toward the basilica, in a sacrificial ritual to gain special favor from the Virgin. I had a sudden urge to join in, so down on my knees I went, crawling across the plaza, which was paved with coarse stones sizzling in the Mexican sun. I was crawling next to entire families— women carrying babies, ladies in their black-lace Sunday finery, and some very earnest-looking young men. Some people crawled bare-legged over the unforgiving, jagged pavement, turning their knees to bloody pulp (looking similar to Mexican images of Christ, after he had fallen while carrying the cross). At first I was crawling slowly, but then I thought it best to get it over with; so for me it became more of a road race, as I zoomed past the penitent pilgrims and up the steps to the basilica. Inside the church, the floor was made of cool, smooth marble and crawling there was a relief. As I headed toward the altar, I could feel blisters forming on my knees, which is believed to be a very good omen.

PORTRAITS WITHIN THE EYES

In 1929, a researcher discovered an image of a bust of Juan Diego reflected in the eyes of the Guadalupe. In 1962, researchers found two more bust portraits in the eyes, those of Bishop Fuenleal and his interpreter, Juan Gonzales; this apochromatic trio all witnessed the creation of the Guadalupe in 1531. In 1981, an optometrist studying the bust images in the eyes concluded that they conform exactly to the principles of optic reflection, and are in perfect obedience to the laws of curvature of the cornea. It was as if in 1531, a color photo was taken by the Madonna, centuries before the discovery of photography! There is nothing

THE ANTICHRIST AND GRIZZLIES

In Revelation 13:2 the appearance of
the Antichrist is described: "This
beast looked like a leopard, with feet
like a bear's feet and a mouth like a
lion's mouth." In 1792, during an
exploration of the Pacific Northwest,
naturalist Jose Mariano Mozino wrote
of a Sasquatch creature, "It has a
monstrous body, all covered with
black animal hair; the head like a
human, but with eye teeth very sharp
and strong like those of the bear." In
1856, George Gibbs observed that the
creatures were of "a gigantic size,
their feet 18 inches long and shaped
like a bear's." Many times Bigfoot
prints are confused with those of
black or grizzly bears.

APOCALYPTIC BIRTH PANGS

In the apocalyptic age, the birth pangs
of the Virgin are believed to signal
the coming of the Antichrist and the
period of Tribulation. The many
Marian apparitions are thought to
herald the dawn of the Apocalypse.
Mother Earth's birth pangs are seen
in earthquakes, volcanoes, and other
natural disasters—God's warning of
impending judgments to be poured
upon the sinful world. In the Bible, a
volcanic eruption is described thusly:
"Smoke came up from the hole like
smoke from a big furnace. Then the
sun and sky became dark because of
the smoke from the hole." (Revelation
9:2) The devastating earthquake in
Northridge, California is also seen as
a sign—just one more in a long list
for the "State of Disaster."

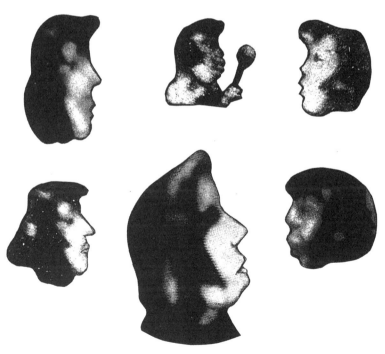

comparable to the pupillarily reflected images in contemporary portrait painting of the period. The actual image surface is mysterious, containing no brushstrokes, no underdrawing, and is made of a material unknown to science—reminding one of the image on the Shroud of Turin.

BIGFOOT REFLECTED

Recently, with the aid of a microscope and computer-enhanced imaging system, I took a look into some pictures of the eyes of the Guadalupe, and was astonished at what I found. Upon deeper investigation into the iris and pupil area of the Virgin's eyeballs, I found a series of images that at first seemed absurd and hard to explain. I catalogued over 75 simian faces, all looking embarrassingly like popular versions of Bigfoot or Yeti (Abominable Snowman). There appeared to be no logical reason for these anthropoid apparitions to be in the eyes of the Madonna. In my investigation, I did not set out to be heretical or blasphemous, but then again I do not have the gift of hierognosis (the ability to discern holy from unholy). It was a discovery that I almost discounted until I understood the role of the Virgin in the Biblical scheme of things.

The Virgin, or the Woman, is constantly at war with Satan, a.k.a. the Devil, Serpent, and/or Beast. ("She shall crush thy head and thou shalt lie in wait for her heel." Genesis 3:15) The word *guadalupe* is derived from the Aztec words *te coatlaxopeuh*, meaning "stone-serpent-the-crush." The Aztecs believed that the Virgin would crush their stone idol—the fearsome serpent-god Quetzalcoatl. The stone serpent also represents the Satan of Genesis: "And the Lord God said unto the serpent, because thou hast done this, thou art cursed above all cattle, and above every beast of the field; upon thy belly shalt thou go, and dust shalt thou eat all the days of thy life: And I will put enmity between thee and the Woman." (Genesis 3:14-15) In Mexico, the Spanish name for the Devil is the traditional term *chango*, or "monkey." Saint John Bosco (1815–1888) had visions of the Devil and demons, appearing to him as "monkeylike beasts" with tails, horns, paws, and sharp fangs.

STONED APES

In prehistoric times, Native Americans of the Columbia River Valley carved anthropoid heads, representing a Sasquatchlike beast. Even to disbelievers, it remains a mystery how the indigenous people of the Pacific Northwest developed the idea of carving stone gorilla heads. In his *Prehistoric Stone Sculpture of the Northwest*, which accompanied an exhibition at the Portland Art Museum, Paul S. Wingert describes the stone skulls: "The cranium is shallow, the eyes large, protruding ovals; the nose wide, convex and terminating in spreading nostrils, and the mouth large, with full lips, and sometimes, partially open. Below the mouth, the protruding face recedes sharply, and in some examples folds of loose flesh are represented under the chin." The Northwest Indian carvings of Bigfoot match the anthropoid heads found in the eyes of the Guadalupe, and were found in the same area as the Boardman Guadalupe manifestation.

On a cliff high above the Columbia Gorge stands the Maryhill Museum, which has a collection of the stone apes. (Reported apparitions of Mary are often seen atop a hill.) The museum is the former rambling mansion of railroad tycoon and eccentric Sam Hill. Next to the Maryhill is a fake concrete Stonehenge, which is superior to the original fallen-down monolith on Salisbury Plain—in Sam's version not a block is out of place. Sam Hill's burial crypt is right there too, turning the entire monument into a monolithic necropolis.

THE IMAGE OF THE BEAST

In their book, *The Many Faces of Mary: A Love Story*, authors Bob and Penny Lord detail the moment when Juan Diego unfurled his poncho for the bishop, revealing the miraculous image of the Virgin: "Our Lady would be there, but the evil one would also be in attendance. Satan had been in control of Mexico for the last ten years. He had reason for not wanting this sign to come to the attention of the bishop." In 1790, Seeress Anna Maria Taigi prophesied of the end time: "The air will be infested by demons, who will appear under all sorts of forms." The fifteenth-century engraver Martin Schongauer made a work entitled *The Temp-*

ANGRY VOLCANO

At the foot of the Mount St. Helens
volcano there is a network of under-
ground hollow lava tubes that extend
for miles called "Ape Caves." In the
early 1940s, a group of Boy Scouts
were frightened by a Bigfoot on the
slopes of the volcano. In the summer
of 1955, hikers from a Y.M.C.A. camp
at Spirit Lake on Mount St. Helens
reported seeing a Bigfoot standing
at the edge of the water.

Upon the eruption of Mount
St. Helens in 1980, Spirit Lake boiled
with sulfur and ash. The Book of
Revelation describes a similar
occurrence: "The false prophet and
the Beast were thrown alive into the
lake of fire that burns with sulfur."
(19:20) Some believe that a Bigfoot
family was instantly vaporized at
the volcano's eruption. One must
remember that Mount St. Helens
is named after Saint Helena, who
is notable for finding the Spear
of Destiny on Mount Calvary near
Jerusalem.

ANOTHER SIGHTING

After my friend Cameron crawled up
to the Guadalupe, he looked into Her
eyes and thought he saw a portrait of
himself in the act of crawling.

tation of St. Anthony (c. 1470), which shows the saint carried aloft
by a host of devils. The scene depicts a plethoric catalogue of
demons, mutated from various grotesque animal species, many
taking on monkeylike forms. The apparition of demons to this
saint was a favorite theme for artists in the Middle Ages. The
appetite for demonic imagery also expressed itself in cathedral
architecture in the form of the gargoyle, or waterspout.

Could it be that in 1531 when the Guadalupe saw Juan
Diego, the bishop, and the interpreter, she also saw her old
adversary the Beast, and *all* were reflected in her eyes? Could
the preternatural reflections be evidence of a diabolical six-
teenth-century apparition? It was as if when Our Lady saw the
Beast, her eyes acted like the segmented eyes of an arthropod,
reflecting a mob of demons, or the many-faceted incarnations of
Satan.

Even Martin Luther, the German Reformer, saw the Devil
in various forms. It is very important for the seer to interpret the
visionary experience in full context, or a wrong or faulty inter-
pretation may result. The Devil has been known to mix fact with
illusion, impressing false images upon the mind. Authentic phe-
nomena must be distinguished from mass hysteria, or the work
of hoaxers. Believers may choose to believe, or not believe,
according to their own heart, without being penalized.

Portland, Oregon
March, 1994

POSTSCRIPT: ADDITIONAL SIGHTINGS

Many other images have been found, and still many more claims
have been made to images in the eyes of Our Lady of Guadalupe.
Likenesses such as a shroudlike portrait of Christ, several pro-
files of Elvis (either looking up in adoration, or with eyes closed
as if in prayer), and an image that looks somewhat like folk

singer Bob Dylan (during his "Born Again" experience) have
been seen. Also sighted are: a diabolical visualization of cult
leader Charles Manson, an image of famed Mexican wrestler and
political activist Superbarrio, a profile of President Abraham
Lincoln, and the carcass-imprint of Blinky, the Friendly Hen.

Los Angeles, California
April, 1994

SOURCES

The Cabinet of Curiosities, by Simon Welfare and John Fairley
Christian Symbolism in the Evangelical Churches, by Thomas A. Stafford
Everything You Always Wanted to Know About Prophecy, by Dr. Jack Van Impe
Field Guide to the Sasquatch, by David G. Gordon
The Great Prophecies of the End Time, by Bruce Corbin
The Holy Bible, New Century and King James Versions
Manlike Monsters on Trial, by Michael M. Ames and Marjorie Halpin
The Many Faces of Mary: A Love Story, by Bob and Penny Lord
The Mark of the Beast, by Trevor Ravenscroft and T. Wallace-Murphy
Miraculous Images of Our Lady, by Joan Carroll Cruz
Los Ojos de la Virgen de Guadalupe, by Dr. José Aste Tonsmann
Prehistoric Stone Sculpture of the Northwest, by Paul S. Wingert
Relics, by Joan Carroll Cruz
Voices, Visions and Apparitions, by Michael Freze
The Wonder of Guadalupe, by Francis Johnston

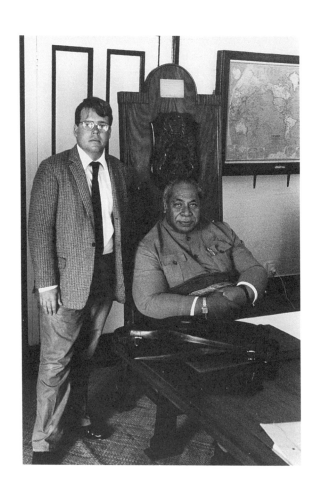

ABOUT THE AUTHOR

Jeffrey Vallance was born in 1955 in Torrance, California. He has had solo art exhibitions at museums and galleries around the world, including Daniel Sorano Hall of National Treasure in Dakar, Senegal; Marc Jancou Gallery in Zurich, Switzerland; Emi Fontana Gallery in Milan, Italy; and Rosamund Felsen Gallery in Los Angeles. Vallance's art projects include "Wall Socket Plate Installation" at the Los Angeles County Museum of Art; "Drawings by U.S. Senators"; and "Cultural Ties," an international exchange of neckwear with heads of state. In addition to those detailed in this volume, his over 30 performances to date include "L.A. City Hall Frisbee Throwing Spectacular" with Mayor Sam Yorty and Mr. Blackwell (Los Angeles, 1973); "The Temptation," a rejection of Vallance's work from the Vatican's Collezione d'Arte Religiosa Moderna (Vatican City, 1989); "Nixon Artifact Conference," at the Richard M. Nixon Library and Birthplace (Yorba Linda, CA, 1990); "Randy Travis Museum" (Nashville, TN, 1992); "Splashing with Barry (Marion Barry Pool Party)" (Washington, D.C., 1992); and "Superbarrio Protest against Televisa" (Mexico City, 1993). Vallance has appeared on *Late Night with David Letterman* (NBC, 1983), and was host of MTV's *The Cutting Edge* (1983); he is also a regular contributor to the journals *Fortean Times*, London, and *Art issues.*, Los Angeles. Jeffrey Vallance lives in Portland, Oregon, and Los Angeles, California.

Other titles available from

Art issues.Press
Los Angeles

The Invisible Dragon: Four Essays on Beauty
by Dave Hickey
Winner of the Frank Jewett Mather Award for distinction
in art criticism.
(ISBN 0-9637264-0-4)

"Dave Hickey is my hero and the best-kept secret in art
criticism, a great mind driven not be necessity but by
desire—erudite, generous, and free. If this book of shocking
intelligence and moral hope is read widely and above all
well, word for word, it will help the world."
<div align="right">

—Peter Schjeldahl
art critic, *Village Voice*
</div>

Art issues., a bimonthly journal of contemporary art
criticism. Ongoing since January, 1989.
(ISSN 1046-8471)

"Literate, sometimes quirky, insightful criticism…a crack in the
boosterish, public relations mentality."
<div align="right">

—*Los Angeles Times*, April 8, 1990
</div>

For further information, contact:

Art issues. Press
8721 Santa Monica Boulevard
Suite 6
Los Angeles, CA 90069

Telephone (213) 876-4508